capture the moment

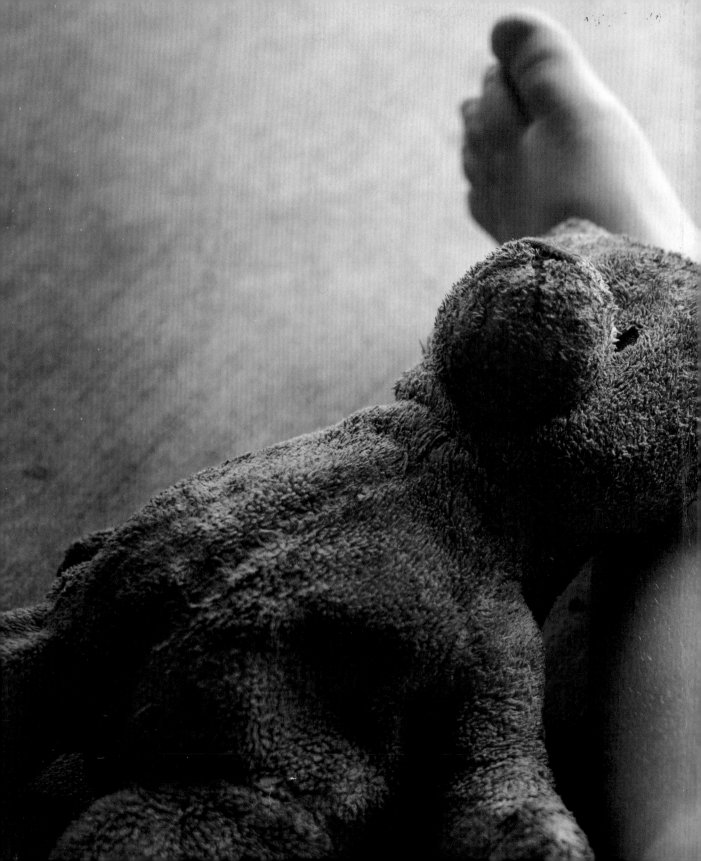

capture the
moment

The modern photographer's guide to finding
beauty in everyday and family life

Sarah Wilkerson CEO, CLICKIN MOMS
photography by the Clickin Moms community

AMPHOTO BOOKS
Berkeley

AMPHOTO BOOKS and the Amphoto Books logo are
registered trademarks of Random House, Inc.

Library of Congress Cataloging-in-Publication Data
Wilkerson, Sarah, 1980-
 Capture the moment : the modern photographer's
guide to finding beauty in everyday and family life /
Sarah Wilkerson.
 pages cm
1. Photography--Technique. I. Title.
 TR146.W459 2015
 771--dc23
 2014030435

Hardcover ISBN: 978-0-77043-527-1
eBook ISBN: 978-0-77043-528-8

Printed in China

This book is dedicated to the Clickin Moms community and to every woman who enriches her corner of the world with her camera.

contents

ACKNOWLEDGMENTS viii

INTRODUCTION 1

CHAPTER 1 **NATURAL LIGHT** 4

CHAPTER 2 **COMPOSITION** 44

CHAPTER 3 **STORYTELLING** 82

CHAPTER 4 **FINE ART** 124

CHAPTER 5 **BLACK & WHITE** 160

CHAPTER 6 **LOW LIGHT** 192

TECHNICALLY SPEAKING: A PHOTOGRAPHER'S REFERENCE 225

CONTRIBUTOR DIRECTORY 232

ABOUT THE AUTHOR 243

INDEX 244

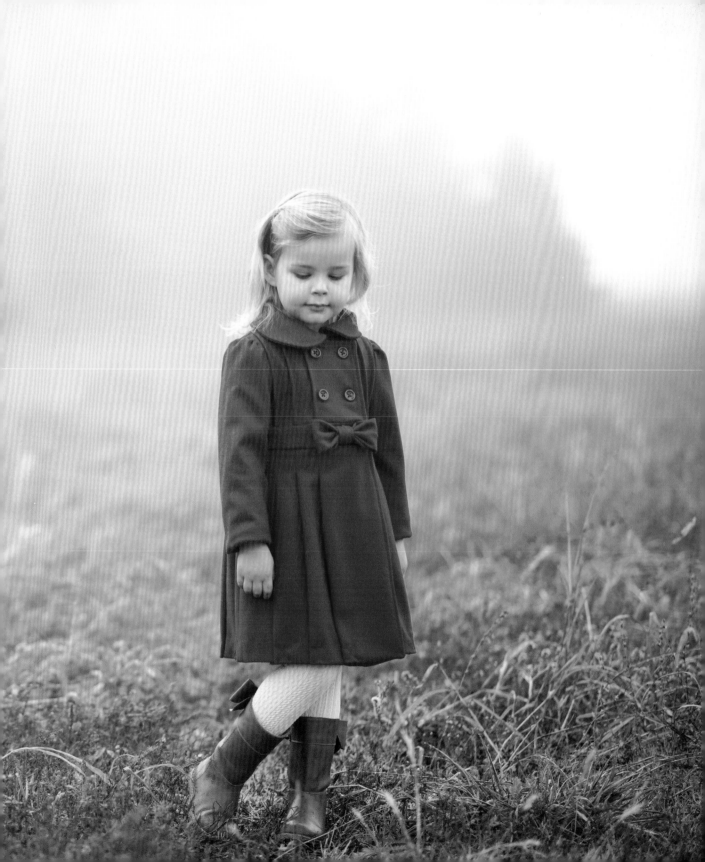

acknowledgments

We are indebted to the talented CMpro photographers whose vision and skill grace the pages of this book. Thank you for allowing us to share these beautiful images that we know will inspire and empower others to begin their own artistic journeys. The unique ways that you see the world through your lenses is an inspiration.

I am so thankful to the people who prepared me for this project and helped me along with its development:

To my husband Malcolm, for the many nights of takeout, letting me sleep in after the nights when work and creative momentum kept me up until 4 a.m., and unconditional support and encouragement in this and every endeavor. I love you so much!

To my mom, who every day inspires the mother I hope to be and the relationships worth photographing. You compiled twenty-three years of scrapbooks that represent every magical memory of my childhood and remind me how important it is to capture everyday moments for my own children.

To my dad, who told me since I was three that I could be anything I set my mind to becoming. Nobody could have anticipated this path, but I do know that I wouldn't be here without the foundation you gave to me.

To my sister Kelly, who has with an enthusiastic and generous spirit celebrated with me every accomplishment and undertaking, big or small, for my entire life.

To Carol Wood, for letting me play with your Nikon D50 in my parents' backyard back in the spring of 2006 and getting me started on this path. You opened this door for me.

To Me Ra Koh, for meeting up with me one afternoon for a lunch that I'll always look back on as a game changer. Your optimism and warmth are

infectious, and your belief in the strength of women in this industry is positively inspiring.

To Julie Mazur, who saw something extraordinary about the Clickin Moms community and worked so closely with me to get this project off the ground. It has been an honor and a pleasure to work with you.

To Amy Lockheart, for the magical cover photo that captures the exquisite convergence of a creative eye, technical mastery, and a mother's love. Thank you, as well, for the ever insightful contributions you made to the development of the book proposal and content.

To Caroline Jensen, Elle Walker, Emma Wood, Jen Bebb, Megan Cieloha, and Michelle Turner for exploring concepts with me and filling in the gaps with your creativity and expertise.

To Julia Tulley, for helping me to organize our many contributing photographers and for always keeping me on track.

To Bill Kelly and Cameron Bishopp, for the dozens of emails you fielded and the consistently thoughtful feedback you gave as the book took shape.

To the team at Watson-Guptill, including designer Ashley Lima, publicist Kara Van de Water, and especially my editor Lisa Westmoreland, who patiently and tirelessly worked with me through many (many!) rounds and countless emails to make this book what it is. I could not have imagined what a rich and exhaustive process this would be, but it's been an amazing experience.

And, most of all, to Kendra Okolita, for her unconditional friendship, support, collaboration on this book's concept, and for creating a safe and warm place for women to learn about photography in the first place.

Clickin Moms is contributing 100 percent of the royalties it receives on the sale of this book to Ronald McDonald House Charities as part of our commitment to giving back to the community. Ronald McDonald House Charities and the Ronald McDonald House program provide accommodation for the families of seriously ill or injured children by offering a "home away from home" near the facility where a child is hospitalized. We selected this charity as our beneficiary by a vote of the CMpro community.

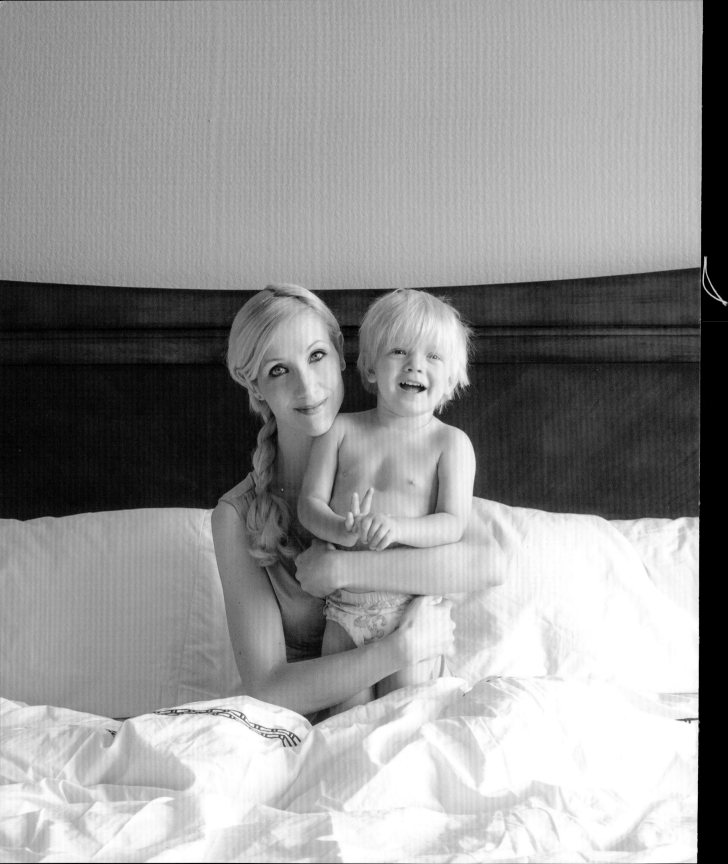

introduction

On a gray Texas morning in 2005, with a ten-day-old baby bundled in the backseat of the car, I kissed my husband good-bye and watched him walk across the parking lot to join hundreds of other soldiers headed for Iraq. The year that he was away was simultaneously the longest and shortest year of my life. Every parent knows the joy and heartbreak of seeing a child grow: the sleepy newborn phase gives way to giggles, and that first belly-inch forward becomes a full-on crawl. "Enjoy it while it lasts," strangers would say with a smile, "this time passes so quickly." It only made me more aware that my husband was missing everything. The milestones wouldn't wait. I ordered an entry-level DSLR and a kit lens, and I dove into shooting and learning. I took it upon myself to become a memory keeper. I sought out beauty in the details of daily life. I documented the nuances of emotion and expression that come and go in an instant. By the time my husband returned, photography had evolved from a way of capturing life to an integral part of my life altogether.

Everyone's story is a little bit different, but when I ask other women why they first picked up a camera, a common theme emerges. Many point to the birth of a child as commencing their journey. For others, loss, growth, or some other pivotal experience precipitated the desire to become a photographer. It's only natural that a heightened awareness of life's transience would lead to an overwhelming desire to begin capturing the moments that pass so quickly and the beauty often overlooked in our fast-paced world.

As the camera becomes an extension of ourselves, we realize the many ways that photography enhances our lives. Not only can we collect a visual representation of our memories for our future selves and others, but we can also use the camera as a vehicle for personal expression. We shoot what we love, letting our photographs represent our values by each subject that we choose to capture and the way we portray it. We become empowered to transform the elements in the frame to convey our moods and emotions. We may embrace the social aspects of the craft, sharing and learning with an ever-growing community of fellow photographers or connecting and engaging with our subjects while shooting. We may discover or develop a business opportunity, using a well-defined style and skill set to provide a professional

service to clients. Or we may simply take an introspective moment for ourselves behind the lens, focusing on the way we want to capture our world and the truth, fiction, or poetry we quietly choose to create.

This book is at its heart a compendium of art and visual stories drawn from the portfolios of photographers across the globe, many of them working professionals, some independent artists, most of them mothers, all of them women. Each image wonderfully exemplifies the compositional principle, artistic technique, or educational tip that accompanies it. These images were originally created, however, not to demonstrate concepts but to let the ordinary emerge as extraordinary, share a message, or capture a moment in time. The result is a collection of photographs infused with artistry and creative perspectives on beauty that might otherwise go unnoticed.

The images are organized within instructional topic chapters, and the accompanying tips within each chapter progress from elementary to advanced. On each page, our contributing photographers have shared the camera, lens, aperture, shutter speed, and ISO applied in the creation of the image shown. Creativity exercises at the end of each chapter encourage you to explore the chapter principles and coax out further experimentation, imagination, and expression. And if you are new to photography, you may find it beneficial to the review the photographer's reference at the end of the book before you begin or when you come across a term with which you are unfamiliar as you progress.

It is said that photographers view life differently. Everything from the businessman striding down the sidewalk to succulent fruit at a farmer's market to scuffed shoes on the doormat becomes a potential subject in our minds. We can hardly contain ourselves when dusk sets a child's halo of curls aglow, and we love nothing more than an empty room filled with sunshine, the way shadows dance across our kitchen walls as daylight approaches, or the drama of tall trees enrobed in fog. We view rundown structures as feasts of textures and see evening's rush hour as an irresistible collection of lines, shapes, and colors. This book intends to help foster this way of seeing: to make knowledge and instruction accessible, to provide the motivation to advance, to help you illustrate your world powerfully, and—above all—to empower you to embrace a passion as creator of beauty, keeper of memories, and teller of stories.

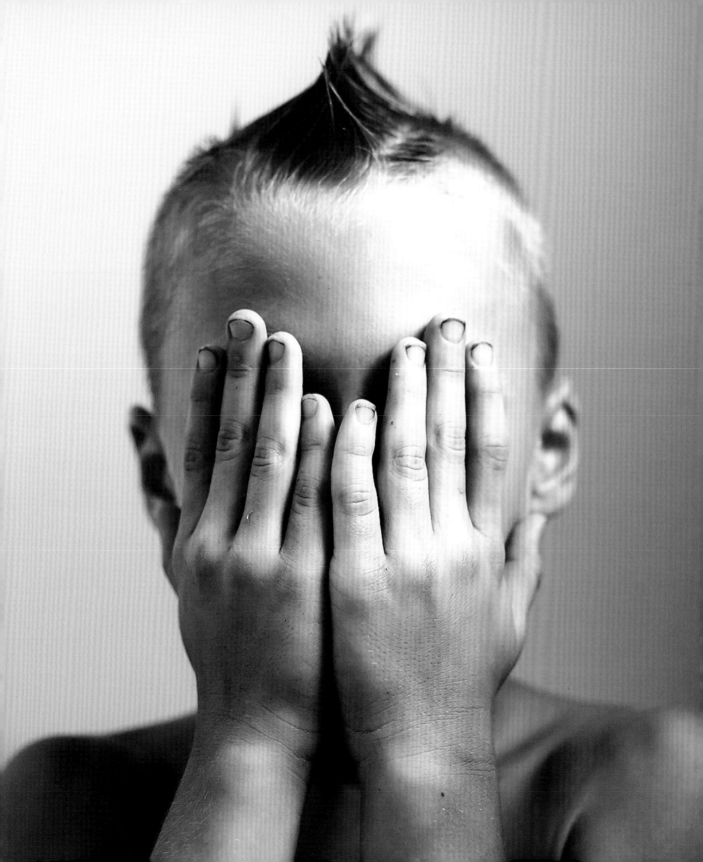

CHAPTER 1

natural light

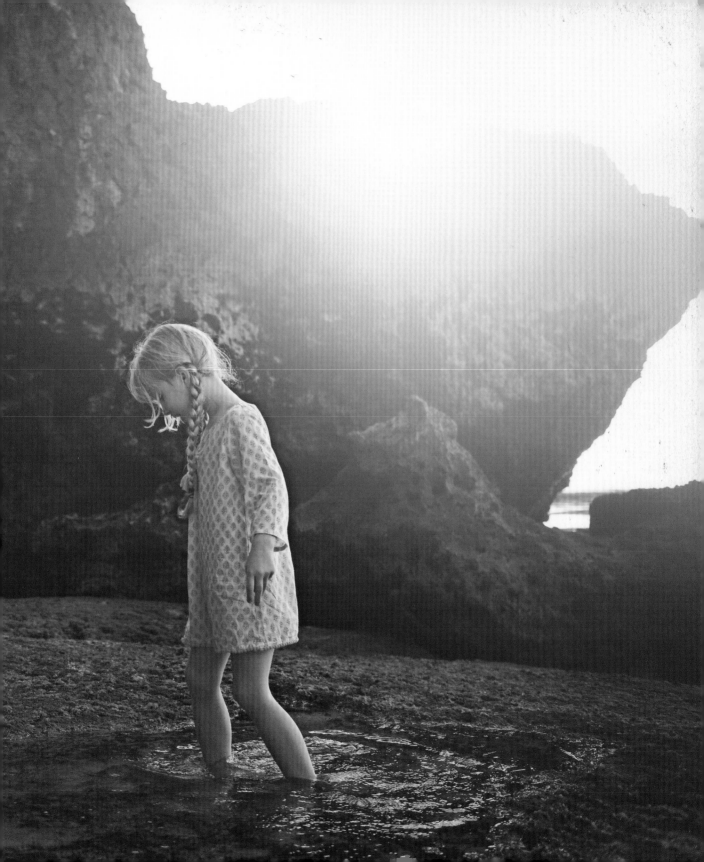

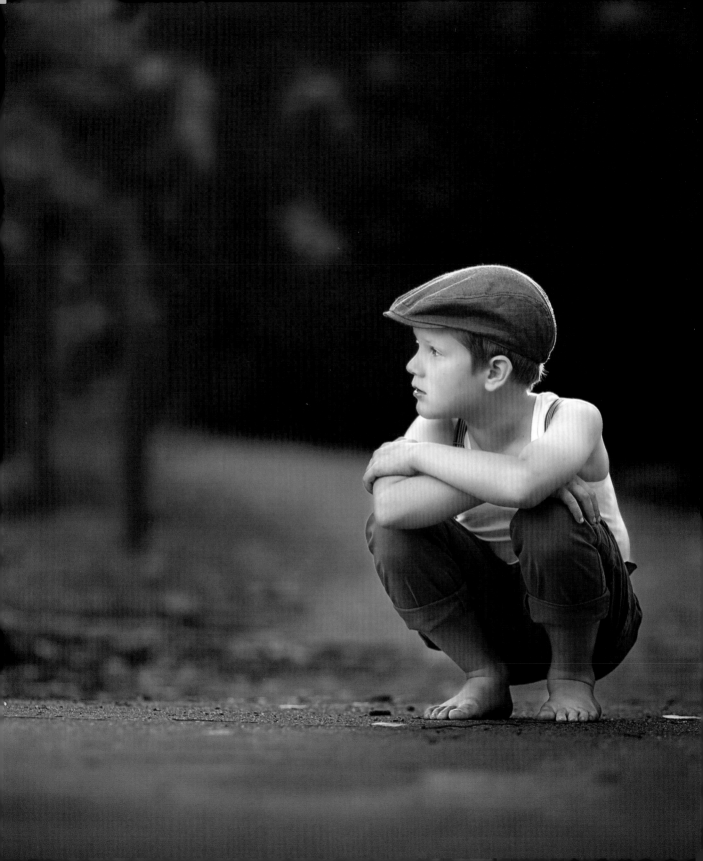

Nothing is so critical to compelling photography as the effective incorporation of light and shadow. After all, photographers are, literally, "writers of light." We need to train our eyes to recognize the way weather, season, time, location, and structural elements influence the color, quality, and direction of natural light. Learning to identify beautiful lighting opportunities and to mold the light and shadow in your images is key to capturing captivating portraits, establishing mood, and illustrating your stories.

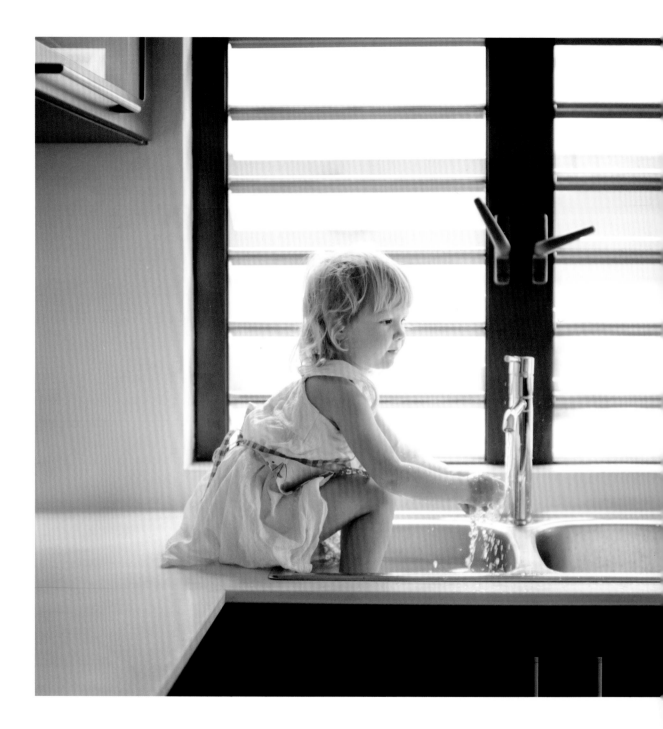

turn out the lights

During daylight hours, turn off overhead lights, lamps, and other light sources in your home before you start shooting. Pay attention to the natural beauty of the light around you, and allow it alone to illuminate your subject or scene.

Sarah Vaughn | NIKON D700 | 35MM
f/1.4 | 1/250 SEC. | ISO 1600

turn off your flash

Avoid red-eye and unexpected bright glares by turning off your camera's automatic flash.
This will greatly improve the quality of your images in most situations.

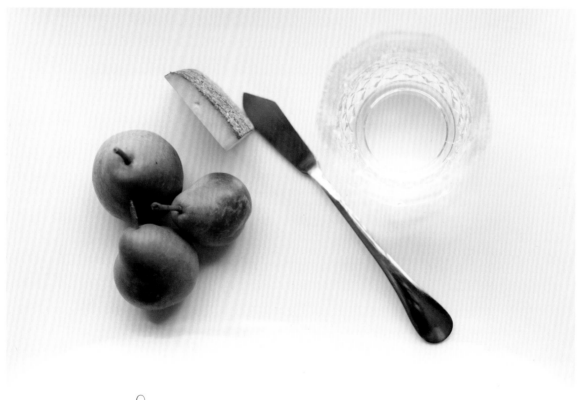

Megan Cieloha | NIKON D700 | 50MM | *f*/2.8 | 1/400 SEC. | ISO 800

keep the light at your back

A general rule of thumb for beginning photographers is to keep the sun behind you. Doing so illuminates your subjects evenly, minimizes shadows, and brings light into their eyes.

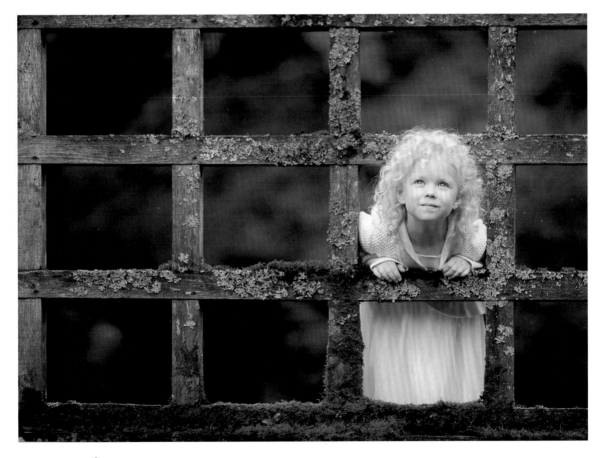

Kristin Ingalls | NIKON D700 | 135MM | f/2.0 | 1/2000 SEC. | ISO 800

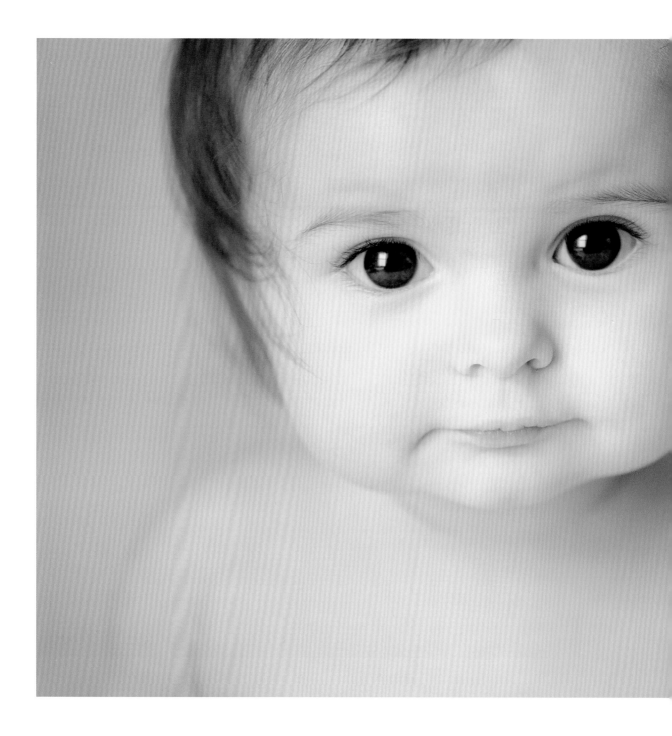

capture the catchlights

Catchlights make the subject's eyes appear bright and full of life. If your subject's eyes look dark or flat, try turning her head or body until you see reflections of light appear in them. It may also help to have your subject tilt her chin up slightly toward your light source.

Beira Brown | NIKON D700 | 105 MM
ƒ/3.0 | 1/250 SEC. | ISO 500

seek out window light

Large windows that allow sunlight to spill into the home are one of the most beautiful sources of light available to photographers. North- or south-facing windows in particular tend to yield soft, attractive light.

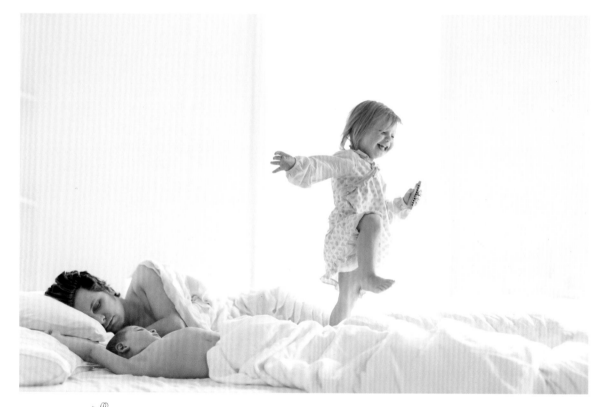

Jill Cassara | NIKON D700 | 85MM | *f*/1.4 | 1/320 SEC. | ISO 3200

pull the curtains

If you have east- or west-facing windows, you may find that direct window light is too intense early or late in the day. In such situations, gauzy, neutral curtains can be used to help diffuse the light, and the result is heavenly.

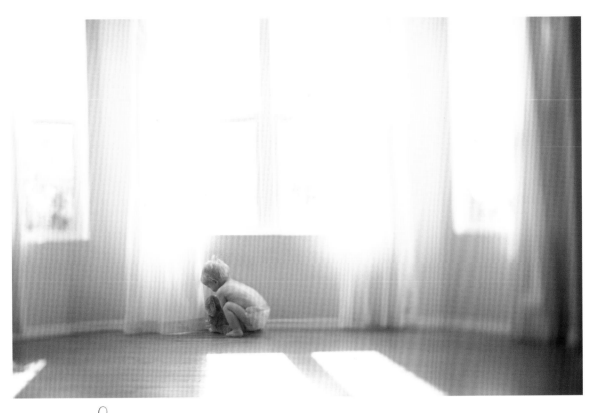

Sarah Wilkerson | NIKON D3S | 45MM | ƒ/2.8 | 1/320 SEC. | ISO 200

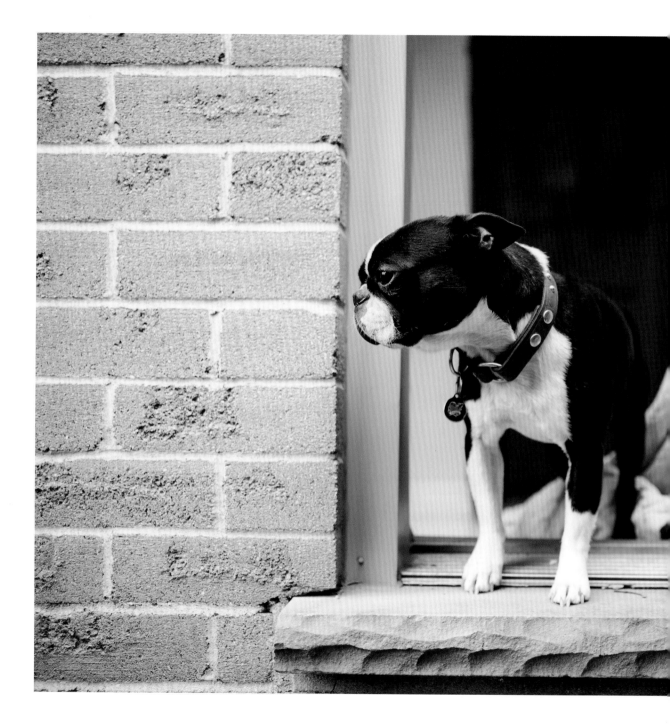

utilize doors and doorways

Don't have large windows at home? Throw open your front door to let light stream into the room, or ask your subject to sit or stand just inside the door frame while you shoot from outside.

Sarah Lalone | CANON EOS 5D MARK II | 35MM
f/1.8 | 1/400 SEC. | ISO 100

head out to your garage

Garages are usually a very dark setting, but when you open the garage door, wonderful directional light comes pouring in. You can control the amount and height of the light by opening the garage door only partway.

Amy Lucy Lockheart | NIKON D90 | 30MM
f/1.4 | 1/200 SEC. | ISO 400

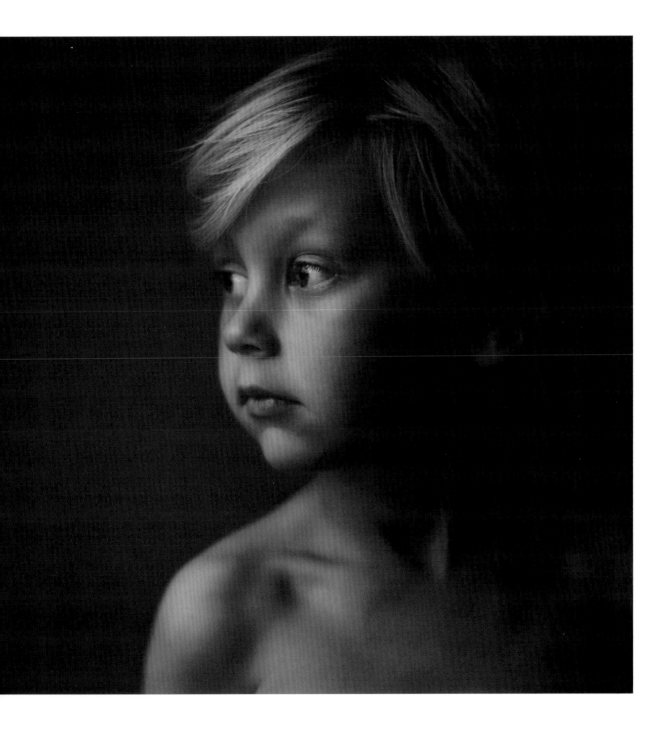

hunt for open shade

Open shade is a soft, evenly lit area beyond the edge of an area of direct sunlight. Look for open shade adjacent to a dense canopy of foliage; beneath open outdoor structures such as porches, covered bridges, or gazebos; or along the side of a wall that blocks direct sunlight.

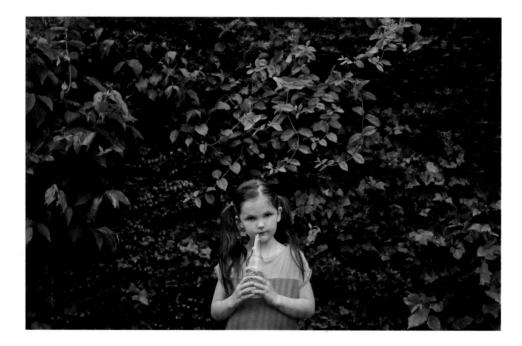

Kara Orwig | CANON EOS 5D MARK II | 70MM | *f*/2.8 | 1/400 SEC. | ISO 320

find a pocket of light

Broad, even light is not necessarily preferable. In a dark house, heavily wooded area, alleyway, or other setting dominated by deep shade, a pocket of light can be positively magical, so seek out those bright spots amidst the shadows.

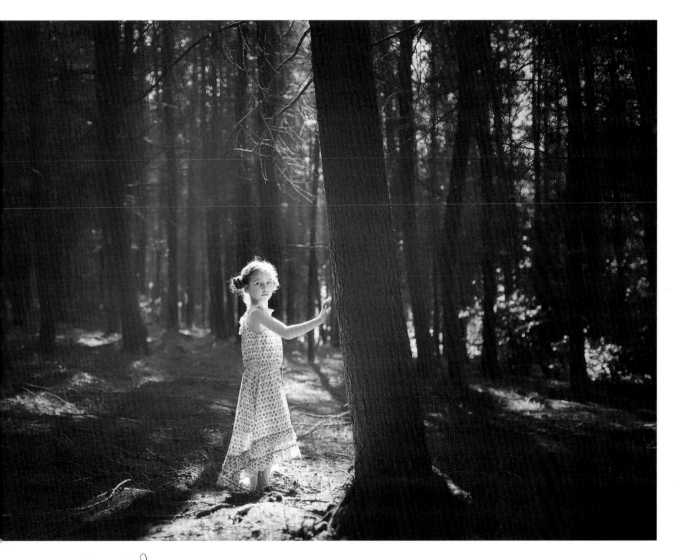

Emma Wood | NIKON D700 | 35MM | f/1.8 | 1/500 SEC. | ISO 400

use directional light to give your subject dimension

Light that streams in from one direction lifts the contours of the subject out of the shadows and reveals form, making your subject look more three-dimensional.

Ardelle Neubert | CANON EOS 5D MARK III | 85MM

f/1.4 | 1/160 SEC. | ISO 800

shoot during the golden hour

During the periods immediately following dawn and preceding dusk, the world is bathed in honey-colored light, and subjects seem to glow. It's the favorite lighting for many photographers due not only to the warm atmosphere but because the low position of sunlight wraps subjects and the landscape from the side rather than bearing down from overhead.

Sarah Cornish | CANON EOS 5D MARK III | 24MM | f/1.8 | 1/8000 SEC. | ISO 125

make the most of an overcast day

You don't need sunshine and blue skies for a beautiful image. Overcast skies—often called "God's Softbox"—provide soft, even lighting that is easy to work with. Because such evenly lit scenes tend to lack the tonal contrast and form created by light and shadow, however, it's important to create additional visual interest with other design elements, such as strong lines, shapes, or pops of color.

Chloe Ramirez | NIKON D700 | 135MM | f/2.8 | 1/320 SEC. | ISO 320

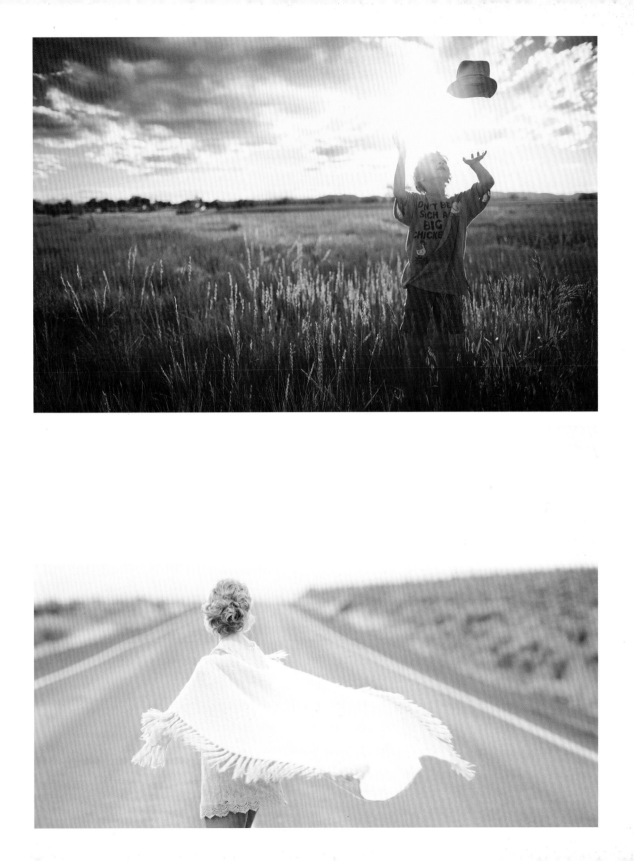

learn to love full sun

When the sun is high in the sky, the light beams directly on the top of the head, causing harsh, unappealing shadows to fall on the face; however, you can create directionality by tilting the subject's chin up toward the sun. You can also filter, funnel, or feather sunlight by blocking the downward path of light with a hat, umbrella, scarf, or hood.

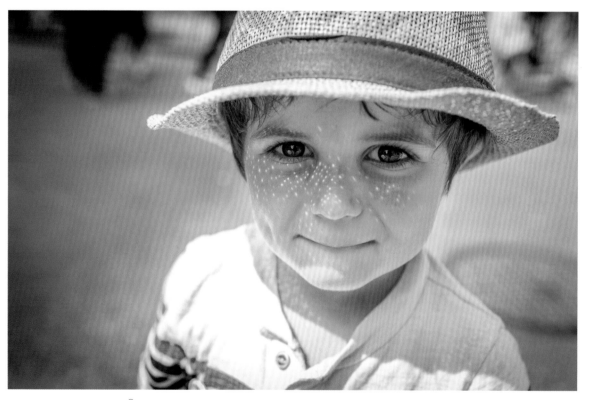

Stacey Vukelj | CANON EOS 5D MARK III | 35MM | ƒ/3.5 | 1/2500 SEC. | ISO 400

work with backlighting

Backlighting is created by placing the subject between the photographer and the light source. If the subject is facing the camera, the light illuminates the subject from the back rather than overhead or from the front. When you correctly expose your subject, the backlighting will reveal a bright, magical halo as it shines through the hair and around the subject's body. Backlighting is ideal around dawn or dusk, when the light is golden and the sun is low in the sky.

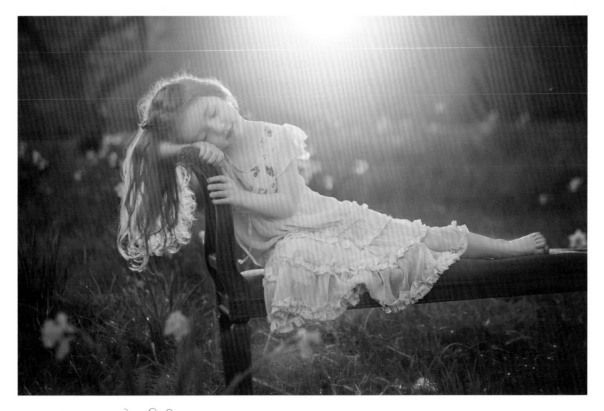

Sally Kate Mothoek | CANON EOS 5D MARK II | 100MM | f/3.5 | 1/320 SEC. | ISO 320

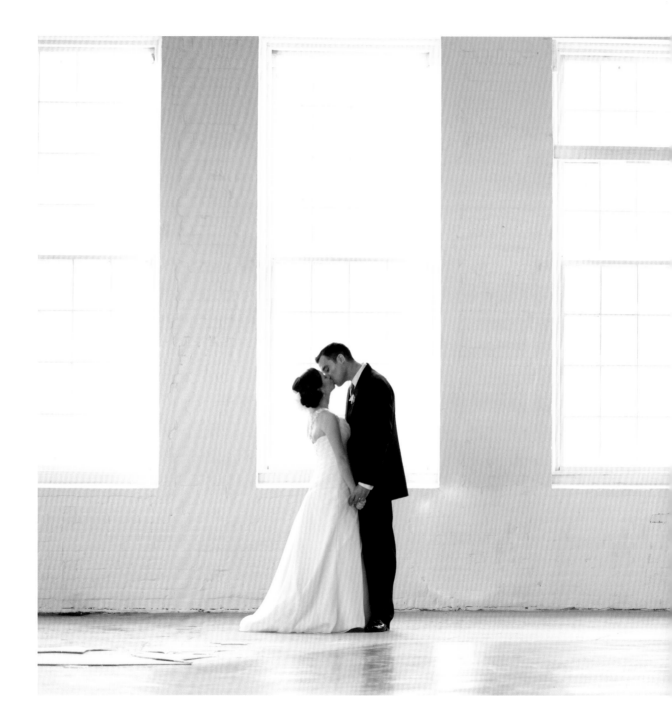

blow out your windows

Backlighting can also be used effectively with midday light when a subject is standing directly in front of an open door or bright window. Unlike warm sunset backlighting, daytime backlighting is bright, clean, and airy. Switch to spot metering and/or manual exposure in order to properly expose your subject and "blow out," or overexpose, your background.

Megan Moore | NIKON D700 | 70MM
ƒ/2.8 | 1/160 SEC. | ISO 800

capture silhouettes

Rather than exposing for your subject when shooting into the light, expose for the very bright background to reduce the subject to a simple silhouette. Try using this dramatic approach to maintain the rich colors of a sunset sky or to present the looming shape of a dark, mysterious subject.

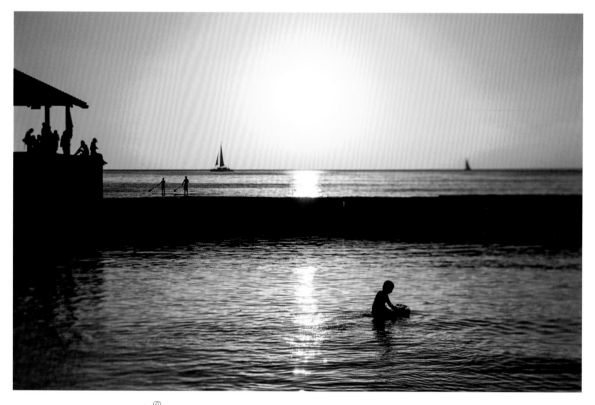

Renee Bonuccelli | NIKON D600 | 80MM | f/2.8 | 1/4000 SEC. | ISO 100

observe changing light throughout your home

The light and shadows throughout your home will change as the sun takes its journey through the sky each day. Pay attention to the distribution and quality of the light in each room from morning to night, and work that knowledge into your photography.

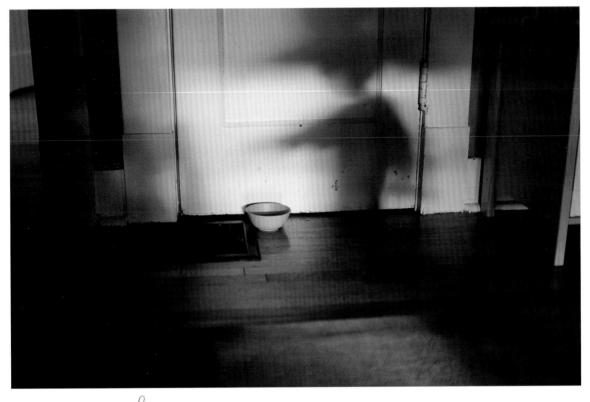

Alana Rasbach | NIKON D700 | 35MM | f/2.0 | 1/200 SEC. | ISO 800

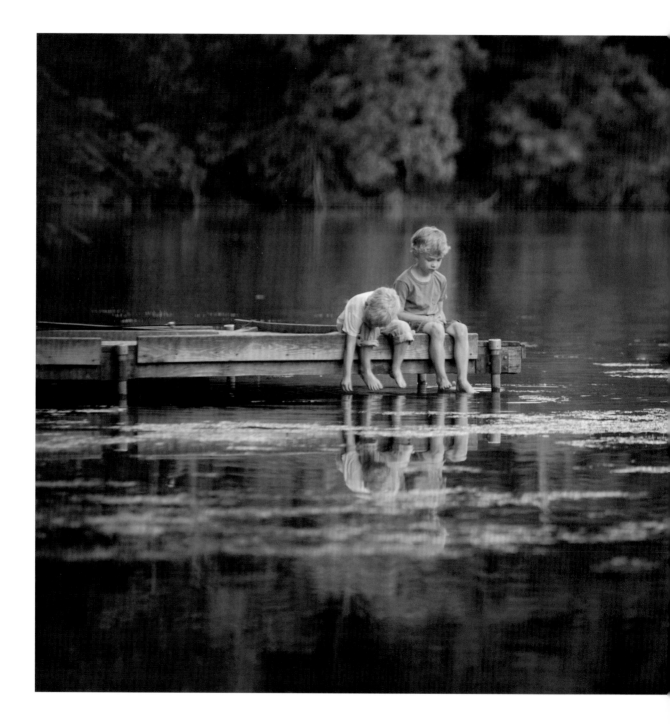

learn the colors of light

The color of light changes significantly depending on time of day, weather, and the presence of shadow. By learning the colors of light, you can take control of the way your camera handles color. Use your camera's presets to specify your light source (such as Daylight or Shade), or if you can set the color temperature directly, dial in 5500 K for average daylight, 4000 K for early evening (as shown here), 3000 K for sunrise or sunset, and 7000 K for light shade. Use the actual color of light as a baseline, then increase your color temperature setting if you want your color to be a bit warmer than neutral, or decrease your color temperature setting if you want your color to be cooler than neutral.

Taryn Boyd | NIKON D700 | 200MM
f/2.8 | 1/500 SEC. | ISO 640

take your cue from rembrandt

Dutch painter Rembrandt van Rijn commonly placed his subjects near small windows, producing a distinctive lighting effect that creates both drama and dimension. With this type of lighting, one side of the face is illuminated, and the nose casts a shadow across the opposite cheek, yielding an inverted triangle of light that extends roughly the length of the nose. Portrait photographers frequently set up Rembrandt lighting in the studio, but placing your subject at a 45-degree angle from a window, with light bouncing back minimally from the interior environment, is an authentic and effective setup.

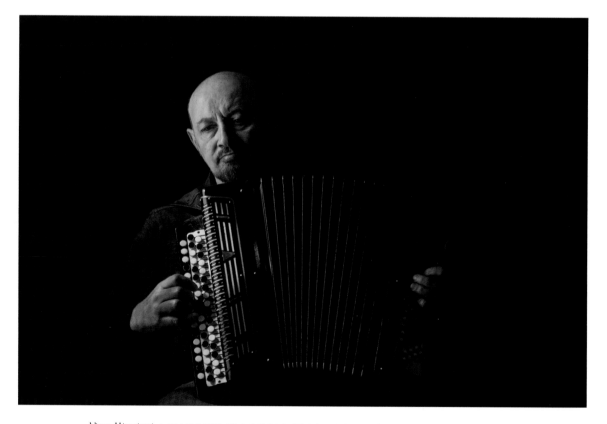

Nina Mingioni | CANON EOS 6D | 85MM | f/3.5 | 1/250 SEC. | ISO 400

feather your light

Feathering the light involves offsetting the subject from the stream of light so that the light passes in front of, behind, or beside the subject. Try positioning your subject with her shoulder facing the window; then have her take a giant step backward so that the window light streams in front of, rather than directly on, her. Though the subject is no longer in the immediate path of the light, she's gently illuminated with soft light that spills over the edges and gives way to soft shadows.

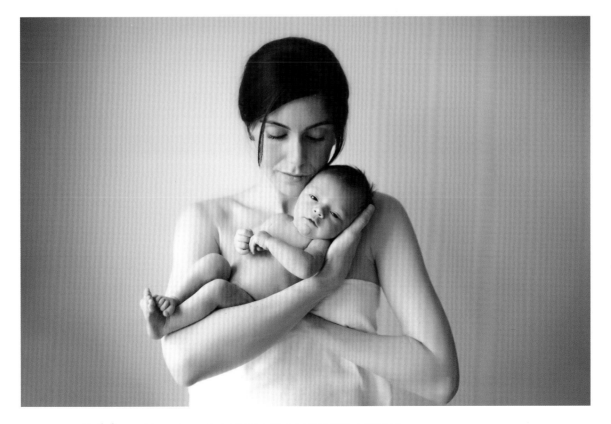

Emily Lucarz | NIKON D700 | 35MM | ƒ/2.0 | 1/640 SEC. | ISO 640

use a reflector

Reflected light bounces off an object and onto a subject, carrying with it the color of the reflective object's surface. Photographers use white (neutral), gold (warm), or silver (cool) photographic reflectors to achieve particular effects, but a white poster board works just as well. You can also seek out natural reflectors in the environment such as snow, water, sand, light-colored walls, white linens, and similar surfaces.

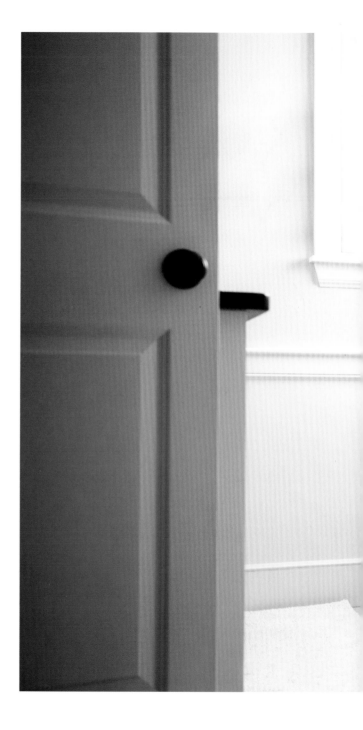

Kelly Wilson | NIKON D700 | 38MM
f/3.2 | 1/125 SEC. | ISO 640

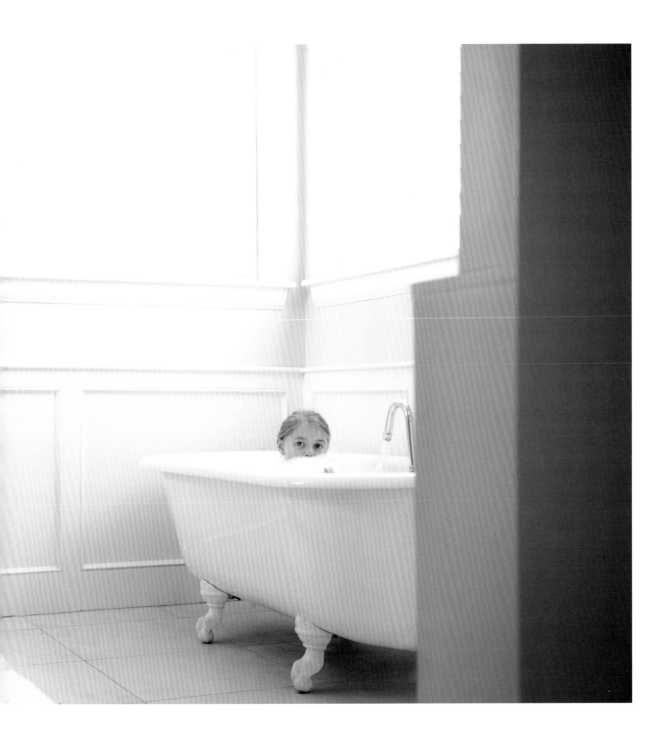

find a light absorber

Whereas white surfaces bounce light back, black or dark-colored surfaces absorb light. Black photography reflectors or naturally dark surfaces cease the continuation of the light's path by absorbing the light adjacent to a subject. This "negative fill" shapes the way the light falls on the subject and produces shadows that create dimension on one side. If you find that your light is too even, try holding a piece of black poster board on one side of the subject to absorb the light and create dimension.

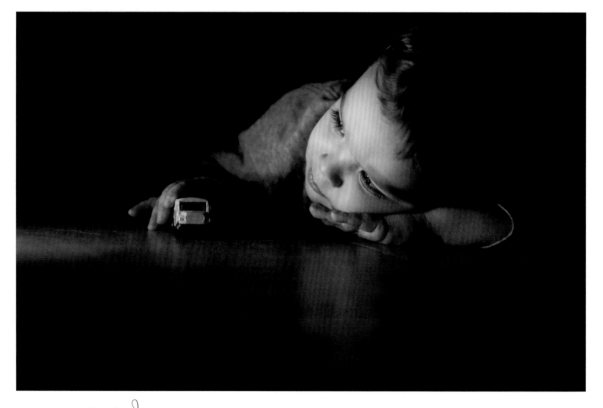

Dana Lauder | NIKON D300 | 35MM | f/1.8 | 1/60 SEC. | ISO 6400

make the best of dappled light

Dappled light is most commonly found beneath trees when light shines right through the branches and leaves, and casts an uneven pattern on surfaces below. Traditionally, photographers avoid such light at all costs, but if you approach it carefully and deliberately, the interplay of light and shadow can add unexpected visual interest. When taking a portrait in dappled light, pay close attention to the way the light and shadow fall on and around the eyes, and expose for the highlights of the skin rather than the shadows.

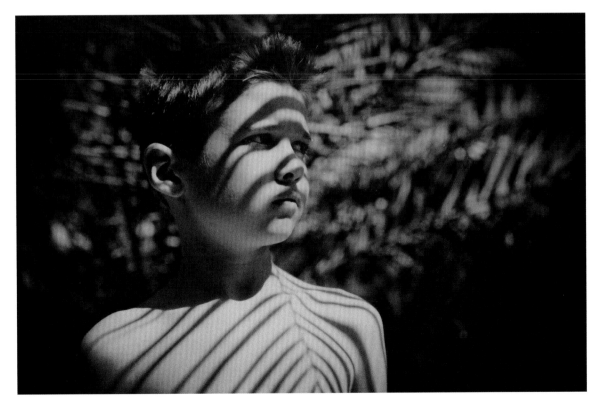

Megan Squires | NIKON D4 | 35MM | ƒ/2.8 | 1/2500 SEC. | ISO 200

embrace
the elements

Inclement weather can provide a wonderful, even mystical, setting for photography. Fog, snow, and rain—in addition to smoke, ash, smog, sand, and dust—add particles to the air that scatter the light and obscure the atmosphere. As a result, elements in the foreground have the most clarity, contrast, and saturation; as the eye progresses into the background, objects become softer, lighter, and duller. Such scenes have a captivating, magical quality and offer opportunities to create beautifully unusual images.

Meg Bitton | NIKON D3S | 195MM
f/3.2 | 1/1000 SEC. | ISO 200

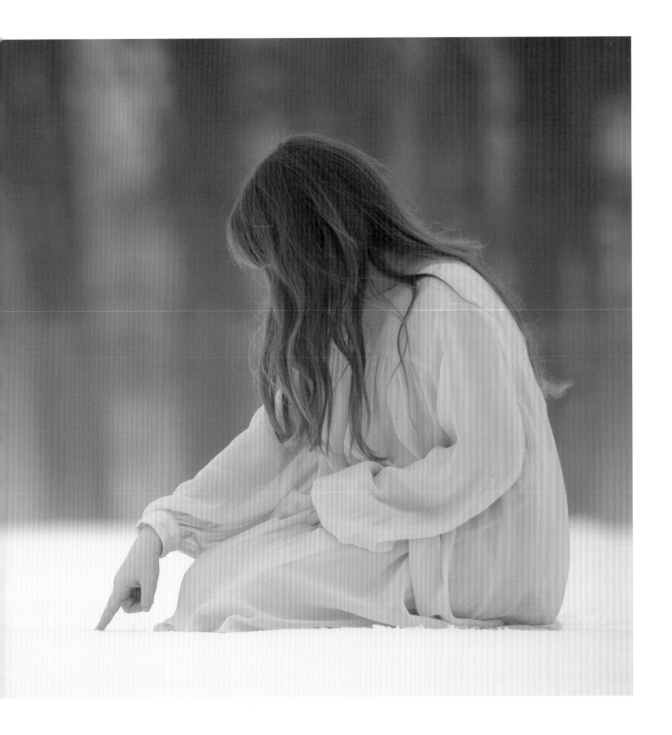

natural light

CREATIVITY EXERCISES

photograph the light

Set aside an hour during the day to explore the light in your surroundings. Rather than looking for interesting subjects, photograph the light itself. Perhaps the light coming through the blinds casts an interesting pattern on the couch, your curtains have a golden glow in the evening, the tree in your backyard yields dappled light beneath, the shampoo bottle in your bathroom is backlit by the sun in the morning, or you can barely see your mailbox at the end of the driveway on a foggy day. Allow the physical objects in the frame to be secondary while the light steals the show.

experiment during the golden hour

What time does the sun set this week? Check the time (and the weather) in advance, and head outside with your favorite model (such as your child, friend, spouse, or neighbor) about ninety minutes before dusk for a Golden Hour shoot. Position your subject for frontlight (light at your back), sidelight (subject's shoulder positioned toward the setting sun), and backlight (subject between you and the setting sun). Also experiment with your camera's color temperature settings, keeping in mind that 3000 K (or the Tungsten preset) will neutralize the light for true whites, and 5500 K (or the Daylight preset) will emphasize the warmth.

get inspired by haystacks

From 1890 to 1891, Claude Monet created a series of twenty-five paintings of a single subject—haystacks—in an observational study of the way the time of day, weather, and seasons affected the color, quality, and angle of light. Start a short personal project inspired by Monet's example. Select an outdoor area or room in your home in which natural light is abundant, and identify or place a simple object (such as a chair, bowl, or potted plant) within it. Photograph this object each day for a month, making notes in a journal as to the time of day, weather conditions, and settings for each shot.

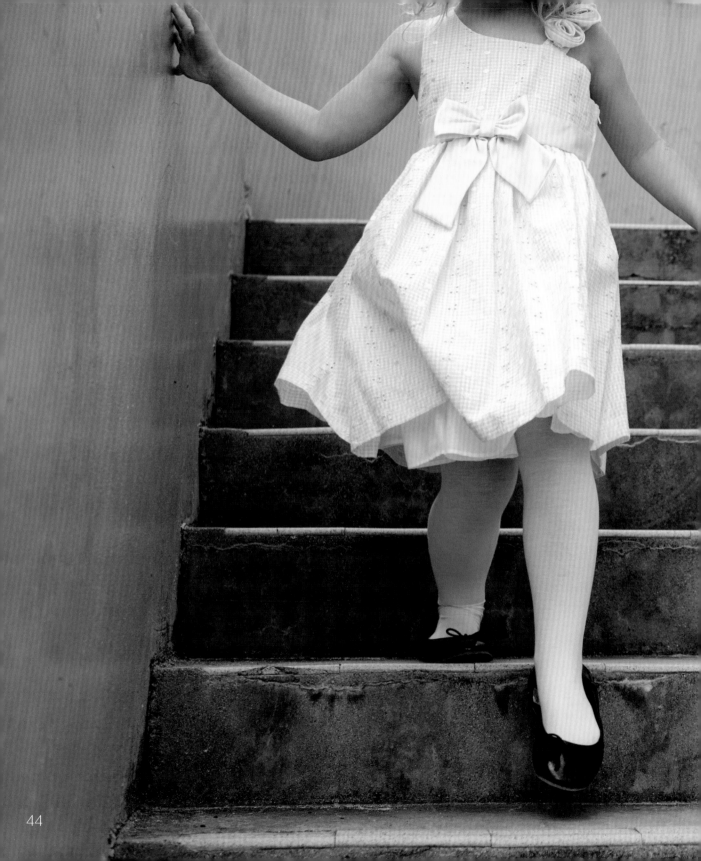

CHAPTER 2

composition

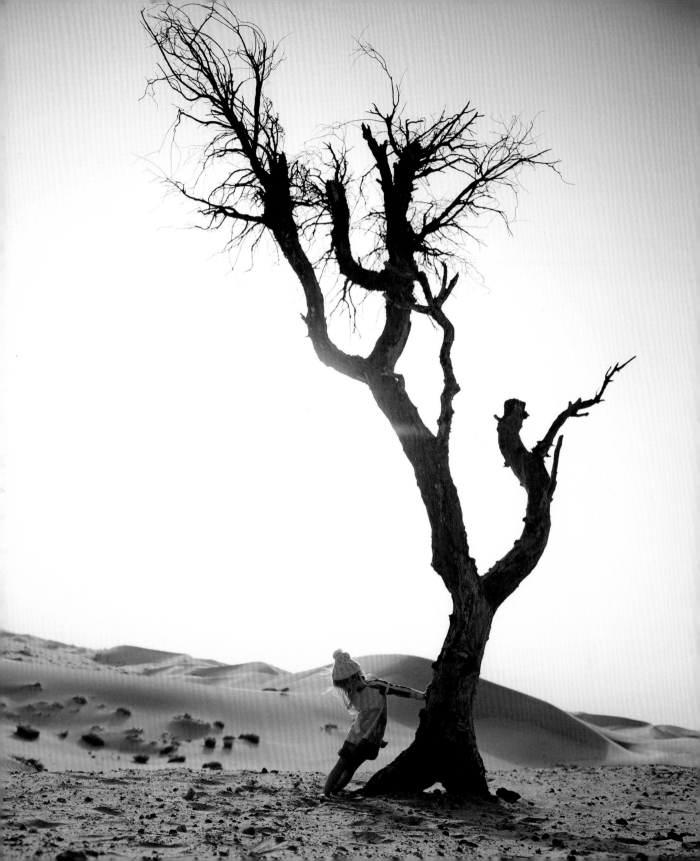

Composition is the art of creating an image
by organizing the elements within the frame
as effectively as possible. The same principles
apply to photographic composition as to
drawing and painting, and many of the rules
of composition are steeped in centuries of
artistry and design. Nonetheless, while
understanding these principles is important,
don't let your focus on compositional rules
overshadow your own thoughtful sense of
beauty. You can often dramatically improve
your composition simply by looking through
your viewfinder a little more carefully.

compose according to the rule of thirds

Perhaps the best-known artistic composition tool, the Rule of Thirds divides a frame into a nine-block grid using two vertical and two horizontal lines. According to the rule, the most important compositional elements should be placed at the grid's intersecting points, and other elements in the frame are often placed along the gridlines themselves. In this image, the child is positioned two-thirds of the way into the frame, and the mattress divides the frame one-third of the way from the bottom.

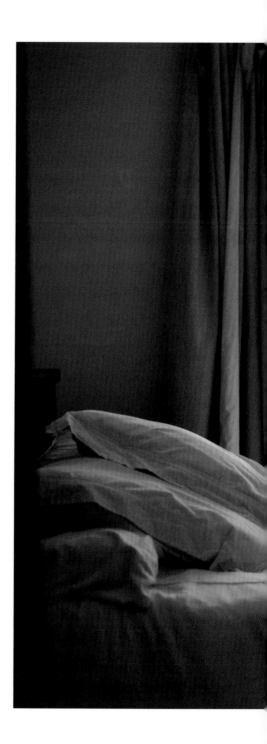

Ginger Unzueta | NIKON D700 | 50MM
f/2.0 | 1/320 SEC. | ISO 2000

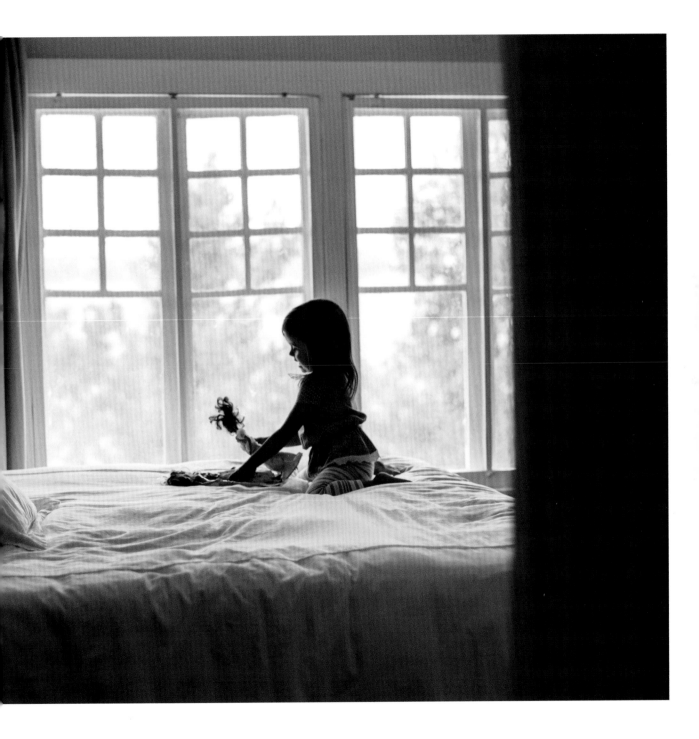

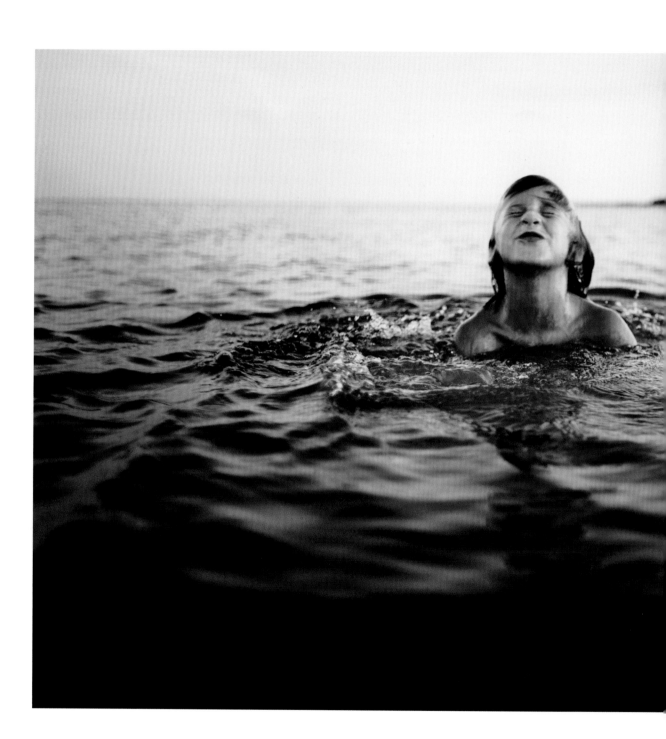

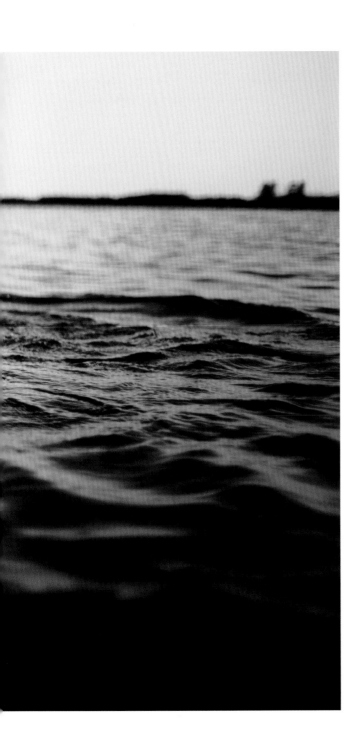

keep your horizon line straight

Horizon lines are the most common lines that appear in photographs, and they anchor the composition. Keep the natural horizon running parallel to the top and bottom edges of the frame as you compose your image in order to establish balance and a solid foundation for the primary elements in the frame.

Deb Schwedhelm | NIKON D700 | 35MM
f/2.0 | 1/3200 SEC. | ISO 320

get down to eye level

Particularly when photographing children and animals, adults tend to shoot from standing level, a natural position of height and dominance. Crouch down to your subject's level to establish a fresh, more intimate perspective that draws the viewer in and creates a powerful connection to the subject.

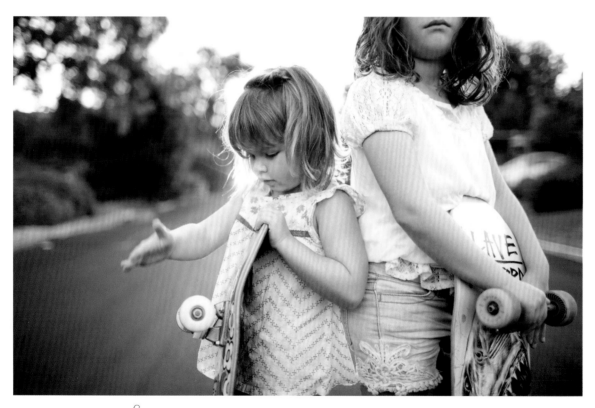

Kristin Dokoza | CANON EOS 5D MARK II | 35MM | f/1.8 | 1/250 SEC. | ISO 1000

change your perspective

Approaching a subject from an unusual vantage point is a wonderful way to elevate everyday objects and scenes. Photograph your subject from behind, from the side, from beneath, and from overhead. You will be surprised how much small movements can dramatically change the effectiveness and appeal of your composition.

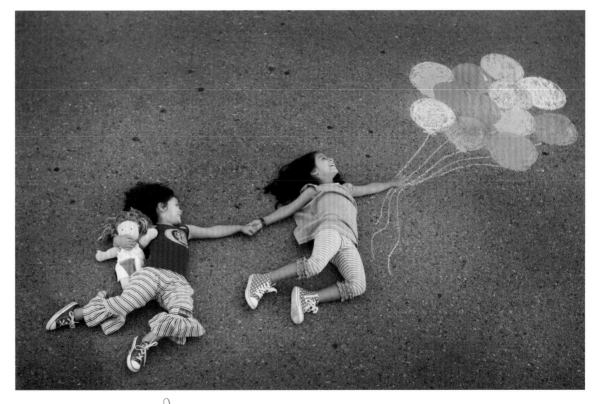

Carrie Anne Miranda | CANON EOS 40D | 30MM | *f*/2.8 | 1/250 SEC. | ISO 100

fill the frame

Compose your image as seems most natural to you; then take two steps closer. You can also use a zoom lens to frame more tightly without physically adjusting your shooting position. By allowing the subject to fill the frame, you'll not only capture rich detail, but you can also eliminate background distractions.

Celeste Jones | NIKON D700 | 85MM | f/2.8 | 1/400 SEC. | ISO 400

include the environment

Pull back to show your subjects in the context of their surroundings. Keep in mind that your lens choice will determine how much of the environment appears within the frame. A telephoto lens has the narrowest angle of view and helps to tidy up a scene, a 50mm lens approximates the angle of view we experience with the naked eye, and a wide-angle lens incorporates the widest swath of background.

Lauren Ammerman | NIKON D700 | 50MM | f/1.4 | 1/60 SEC. | ISO 1000

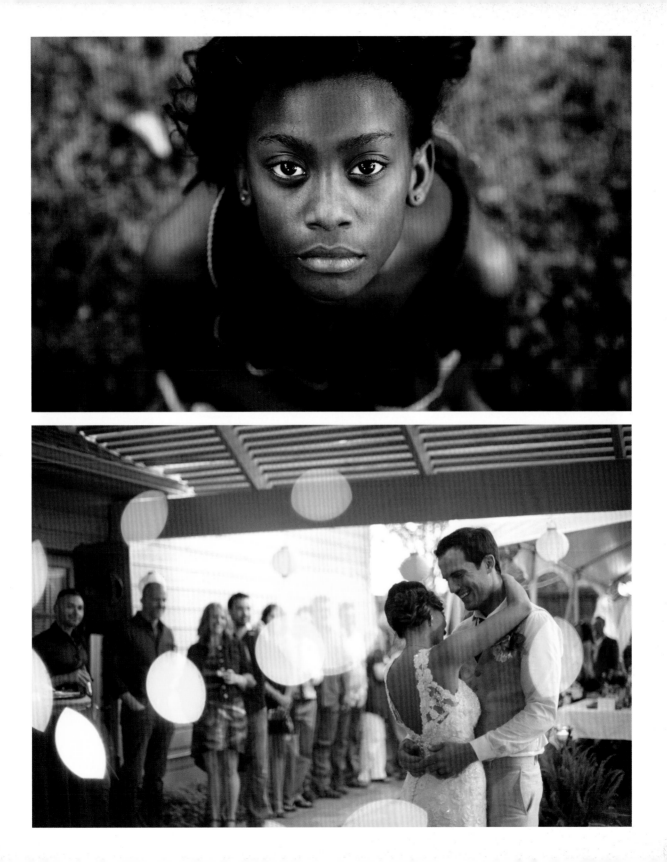

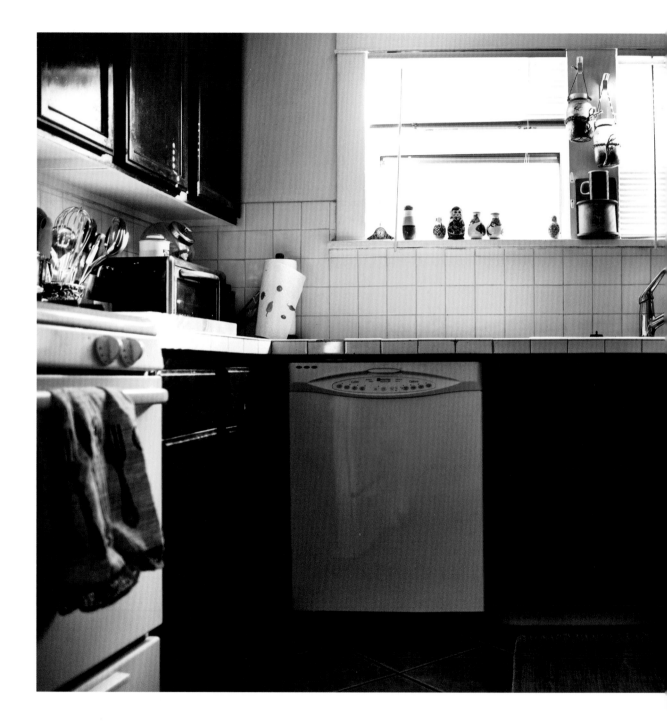

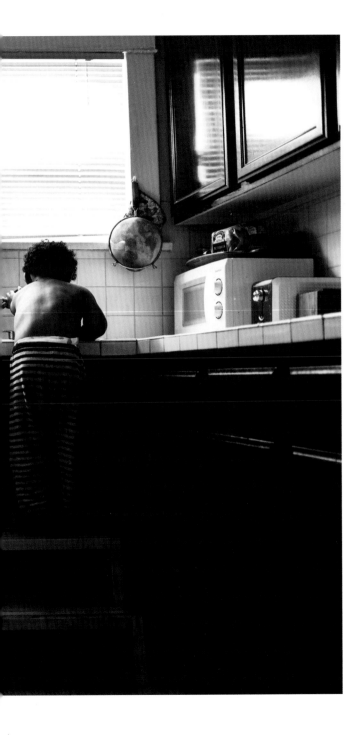

take responsibility for every item in the frame

As an artist, you are responsible for each item that appears in your photograph. Everything within the frame should serve a purpose, whether to provide cues about the story or just to enhance balance or visual flow. That might mean a minimalist image with just one or two distinct elements, or it might mean a more complex image with many visual details (as in this photograph) in which all the elements contribute in some way to your message, scene, or the overall beauty of the photo.

Carolyn Brandt | NIKON D700 | 28MM
f/2.8 | 1/125 SEC. | ISO 1600

minimize distractions

If an element doesn't add to the image, it probably detracts from it. Exclude or minimize elements that don't contribute to your story or design. Creative exposure, changed perspective, or selective focus can all help to isolate your primary subject visually within a complex setting.

Elizabeth Blank | NIKON D700 | 50MM
f/2.8 | 1/125 SEC. | ISO 640

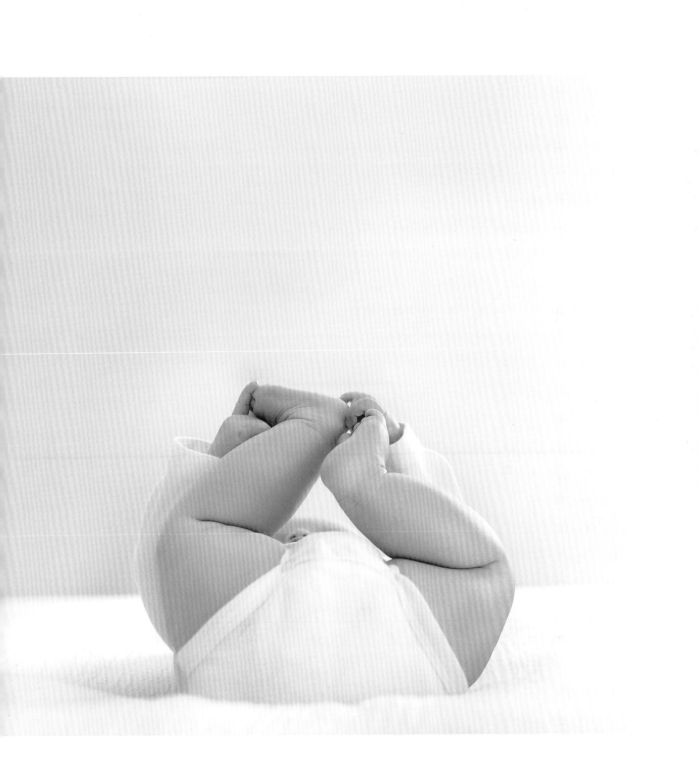

utilize negative space

Incorporating negative space into your photographs can add stability, focus, and intimacy to your image. Seek out a minimalist setting, such as an empty room, blank wall, or wide field; then place your subject at the far right edge or very bottom of the frame so that the viewer's eye will carry across the negative space and hone in on the subject.

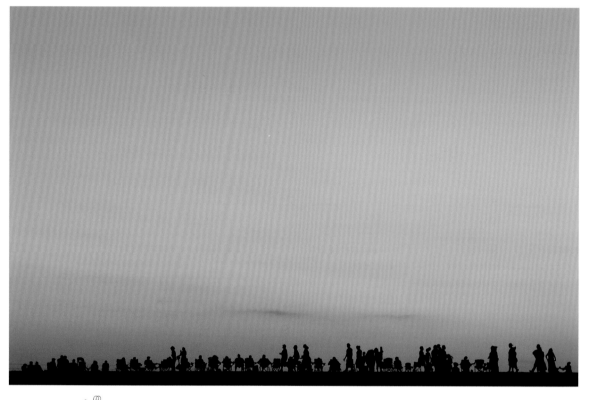

Holly Thompson | NIKON D300 | 50MM | *f*/3.2 | 1/250 SEC. | ISO 200

recognize internal framing devices

Using an internal frame helps to guide the viewer to your subject. Internal frames can add layers, perspective, and context that pull the viewer into the image visually and psychologically.

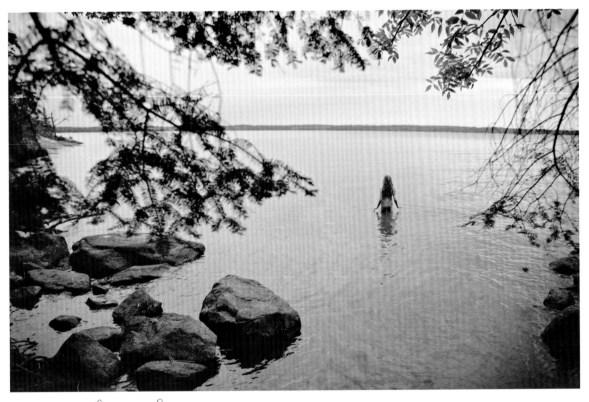

Carol Swaithewich | CANON EOS 5D MARK II | 24MM | f/4.0 | 1/1250 SEC. | ISO 400

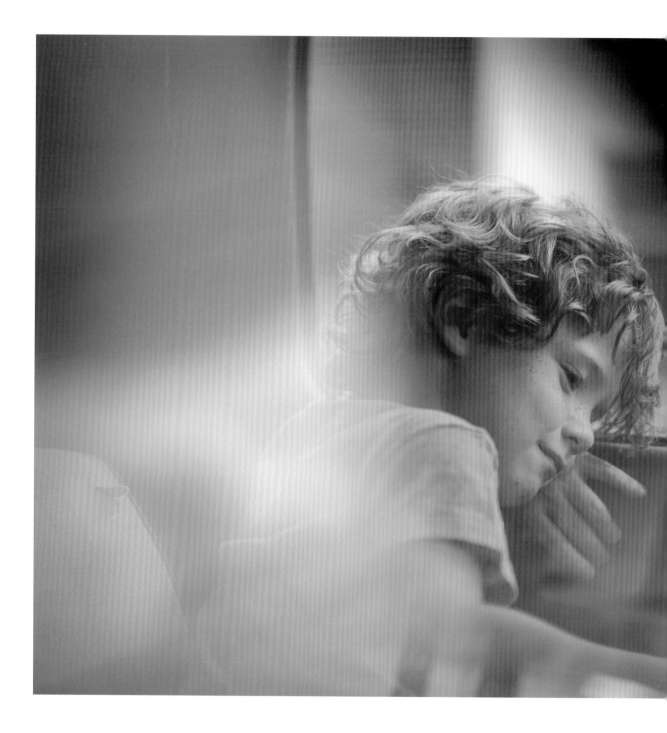

incorporate foreground elements to add depth

Particularly when shooting landscapes, but also with storytelling images (see chapter 3), the inclusion of foreground elements creates depth that beckons the eye into the scene. Soft foreground elements also contrast visually with the selective point of focus, establishing additional balance within the frame and reinforcing the primary subject.

Meg Bitton | NIKON D3S | 85MM
ƒ/2.0 | 1/640 SEC. | ISO 200

consider visual progression

Viewers naturally scan an image the same way that they read written text, and most modern languages progress from top to bottom and left to right. Powerfully familiar elements, including alphanumeric characters and human faces, command a viewer's attention forcefully, as do certain characteristics, such as highly saturated colors, bright tones, high contrast, or great mass.

Liz LaBianca | NIKON D4 | 85MM
f/2.8 | 1/1250 SEC. | ISO 125

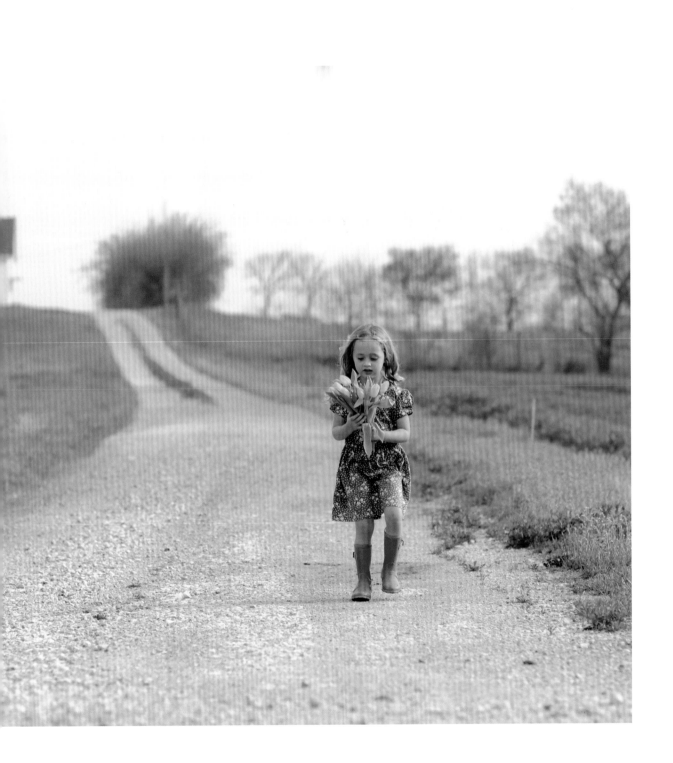

use leading lines

Leading lines create movement and tie image elements together. A leading line may consist of a physical line or an implied line such as an eye line or trajectory. You can use such a line to help guide the viewer through the image or toward the image's focal point, but avoid incorporating lines that unintentionally carry the eye away from your subject.

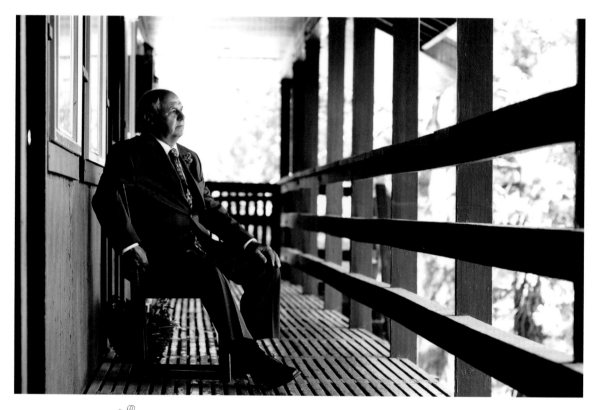

Erin Pasillas | NIKON D7000 | 85MM | *f*/3.5 | 1/100 SEC. | ISO 250

give the lines room to lead

When you have a physical or implied leading line, position it to direct the viewer through the middlemost point of your image from left to right. This ensures that the line leads the viewer into the frame, rather than carrying the eye out of it. This image shows the subjects looking and moving towards the right. Because they are placed in the left half of the photograph, they appear to be gazing and walking into, rather than out of, the frame.

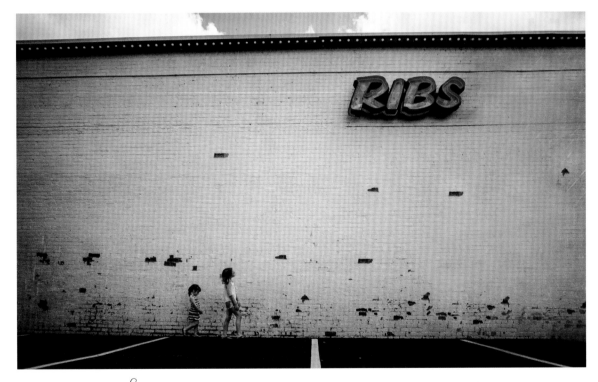

Kate T. Parker | NIKON D800 | 28MM | *f*/3.2 | 1/2500 SEC. | ISO 250

add movement to your image
with diagonal lines

A vertical or horizontal line parallels the existing edges of the frame, but a diagonal line introduces new angles. As a result, including a diagonal in your composition can be a very effective way to bring more life and movement to your scene.

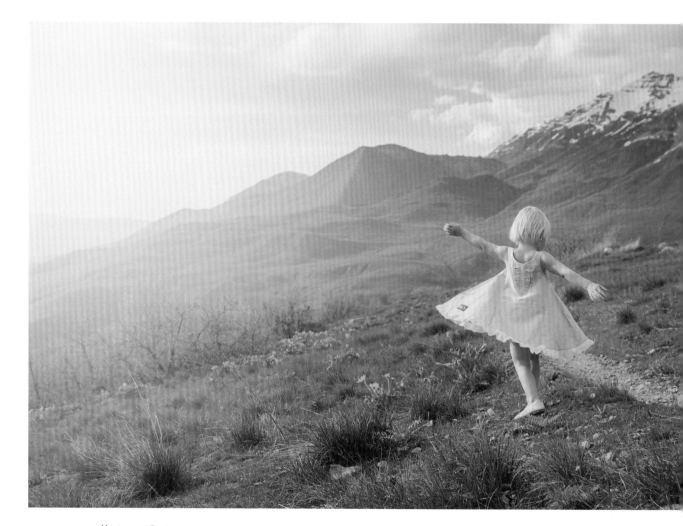

Marie van Sant | NIKON D700 | 32MM | f/4.0 | 1/1250 SEC. | ISO 200

find balance

Balance is an important factor in developing aesthetically pleasing compositions. In fact, the Navajo language expresses *balance* and *beauty* with the same word (hózhǫ). Visual symmetry on the left and right sides of the frame is one way to achieve balance, but asymmetrical elements balanced by size (large versus small), tonality (dark versus light), color, and texture can also be effective.

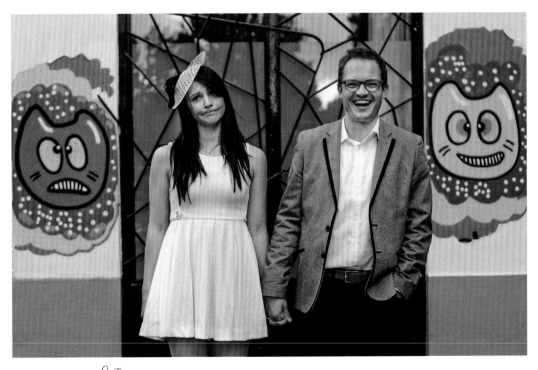

Michelle Turner | NIKON D3S | 35MM | *f*/2.8 | 1/1250 SEC. | ISO 500

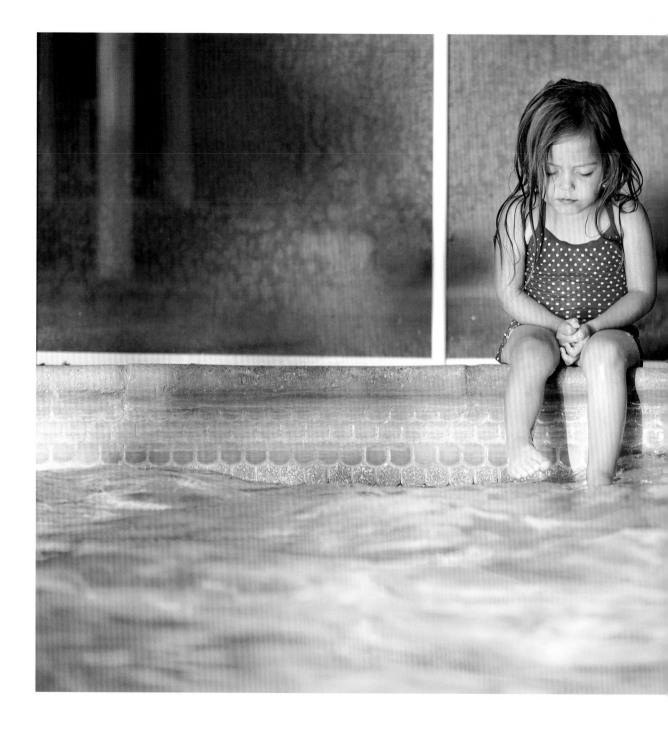

employ chromatic contrast

Complementary colors are color pairs that lie opposite each other on the color wheel, and traditional color complements are red/green, blue/orange, and yellow/violet. Placing your subject against a complementary-colored background is a great way to grab your viewer's attention. For example, capture red tulips in a green field or place an orange-clothed subject against a bright blue sky. For a less explosive combination, temper your pairings with *split complements*: rather than pairing blue with true orange, pair it with orange-yellow or orange-red; rather than pairing yellow with violet, pair it with violet-red or violet-blue.

Stacey Haslem | NIKON D700 | 105MM
f/2.8 | 1/800 SEC. | ISO 200

illustrate size and scale

Include a person in the frame when shooting landscapes, cityscapes, or other scenes in which you wish to emphasize the enormity of the environment. The incorporation of a human figure provides an identifiable sense of scale within the frame and adds an emotionally familiar, psychologically relevant element.

Carol Swaithewich | CANON EOS 5D MARK II
24MM | f/3.2 | 1/2000 SEC. | ISO 500

identify traditional geometric shapes

Composition is fundamentally an arrangement of shapes within the frame. Even organic shapes can be categorized loosely as circles, rectangles, or triangles, but traditional shapes impart a powerfully appealing design aesthetic to a photograph.

Adele Humphries | CANON EOS 5D MARK II | 35MM | ƒ/1.6 | 1/640 SEC. | ISO 500

seek out patterns

Patterns consist of repeated shapes, lines, or subjects. Generally speaking, three or more repetitions are necessary to establish pattern, but even two repeating elements may suggest a pattern if the repetition is extraordinarily striking or unexpected.

Emily Lucarz | NIKON D700 | 85MM | ƒ/3.5 | 1/2500 SEC. | ISO 2500

consider the placement of your primary subject

By placing your subject on the bottom right side of the frame, you give the eye a natural resting point, similar to the end of the page in a book. Other placements may affect the viewer differently. For example, a right-facing subject along the left edge of the frame generates empathy as the viewer comes in behind the subject and then carries forward with that subject's eye line, path, or experience.

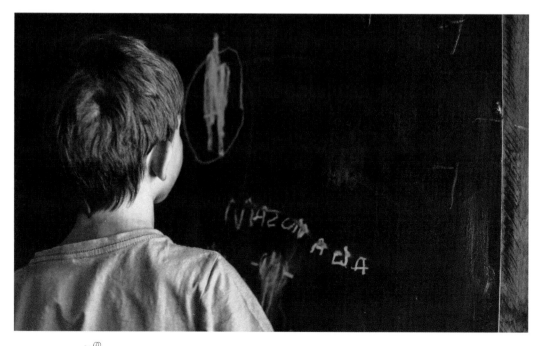

Elle Walker | NIKON D700 | 50MM | *f*/2.5 | 1/160 SEC. | ISO 1600

incorporate and emphasize texture

Texture elevates a viewer's sensory experience of a photograph by suggesting a tactile experience, such as roughness, smoothness, grittiness, waxiness, silkiness, or sliminess. You can heighten texture in post-processing by increasing midtone contrast, sometimes referred to as "clarity," on the textured element.

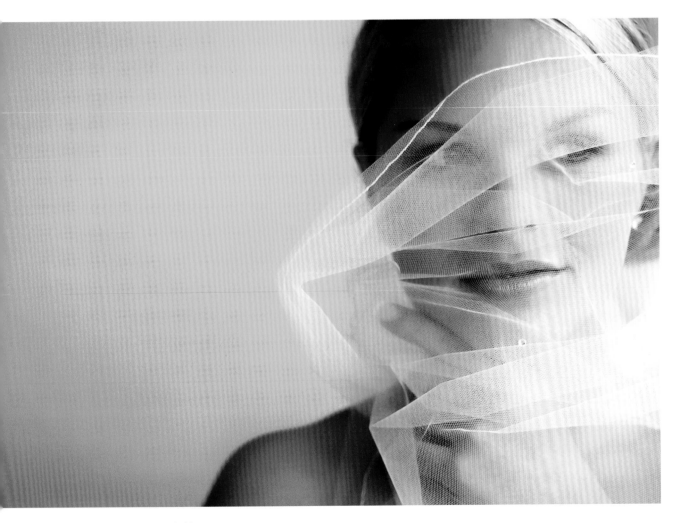

Jen Bebb | CANON EOS 20D | 50MM | f/1.8 | 1/2000 SEC. | ISO 400

know when centering works

Centered compositions work well for photographs that feature architectural symmetry, horizons that divide mirrored sky and water, or subjects emerging from background to foreground. The static qualities we sometimes associate with center placement can have a captivating effect when a photographer deliberately uses center placement to snap the eye to center and suspend it there.

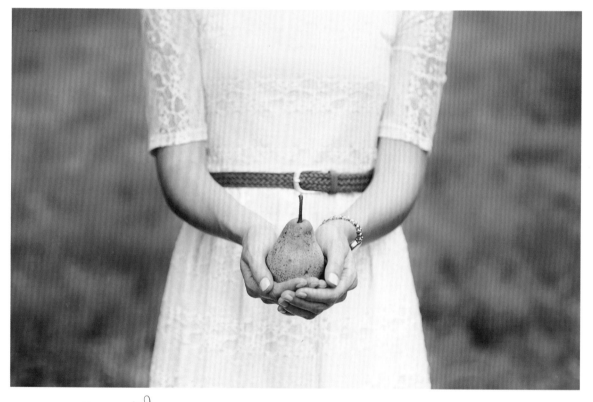

Marissa Gifford | NIKON D700 | 70MM | *f*/2.8 | 1/250 SEC. | ISO 400

utilize "golden" compositions

Compositional frameworks, such as the elegant curves of the Golden Spiral or the powerful diagonals of the Golden Triangles pictured here, are based on the mathematical ratio of 1:phi, or 1:1.618 (see Golden Ratio, pages 226–29). Scientists and sociologists have determined a strong relationship between this ratio (which is found both in nature and in manmade creations) and the human conception of beauty. Try experimenting with one of these alternatives to the Rule of Thirds in your compositions.

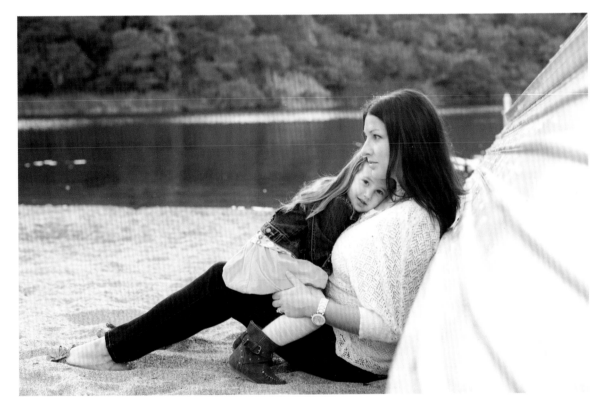

Meg Sexton | CANON EOS 5D | 50MM | f/3.2 | 1/800 SEC. | ISO 640

composition

CREATIVITY EXERCISES

take 24

In a 1971 interview with Sheila Turner-Seed, iconic photographer Henri Cartier-Bresson said, "The difference between a good picture and a mediocre picture is a question of millimeters—small, small differences—but it's essential." Choose a single subject and shoot exactly twenty-four images—equivalent to a standard roll of film. Shoot your first image, take three steps closer, shoot, take ten steps backward for another shot, and then take one small step to the left and shoot again. Bend your knees, stand on tiptoe. Get down on your belly and shoot upward, or climb up on a ladder to shoot from overhead. How does your position or proximity to the subject change the composition and elements within the frame? Where do you need to stand in order to incorporate foreground framing? Take care to ensure that each time you press the shutter, you capture something a bit different.

illustrate the immensity of the environment

Although conventional wisdom often advises photographers to get closer to subjects, doing just the opposite can be equally striking. Grab the widest-angle lens that you have, and then move back from your subject until it occupies less than 5 percent of the frame. Allow the height, breadth, or depth of the environment to dominate. Your subject will appear diminutive by comparison, so take care to help the subject stand out by utilizing tonal contrast, negative space, or complementary colors. For example, shoot a figure in red against the lush greenery of a massive forest or in orange against a sprawling blue ocean and sky or in purple against the sweeping golden sands of a desert.

break the rules

Rules are rules for a reason. In most cases, they promote aesthetics that we associate with artistic harmony and a pleasant viewing experience. While breaking a dozen rules at once is likely to result in a photograph that feels careless and chaotic, deliberately and gently breaking a rule or two can create unexpected visual interest and tension that draws a viewer in. How might rule-breaking strengthen your message or artistic vision? Think about a reason why each rule might exist; then consider when and why you might strive to achieve the opposite effect in your image. For example, a straight horizon creates a strong foundation and an excellent sense of repose, so you might instead choose to introduce a slightly crooked horizon to establish an unsettling imbalance as a man rides his rickety bike down a dusty path, as a toddler takes her wobbly first steps, or in photographing the spooky abandoned house at the end of the street. Consider ways that you can effectively break other rules. For what reasons might you want to place your subject in the top left corner, leave a scene full of clutter, crop edges unevenly, shoot above or below eye level, or have your subject staring or traveling right out of the edge of the frame?

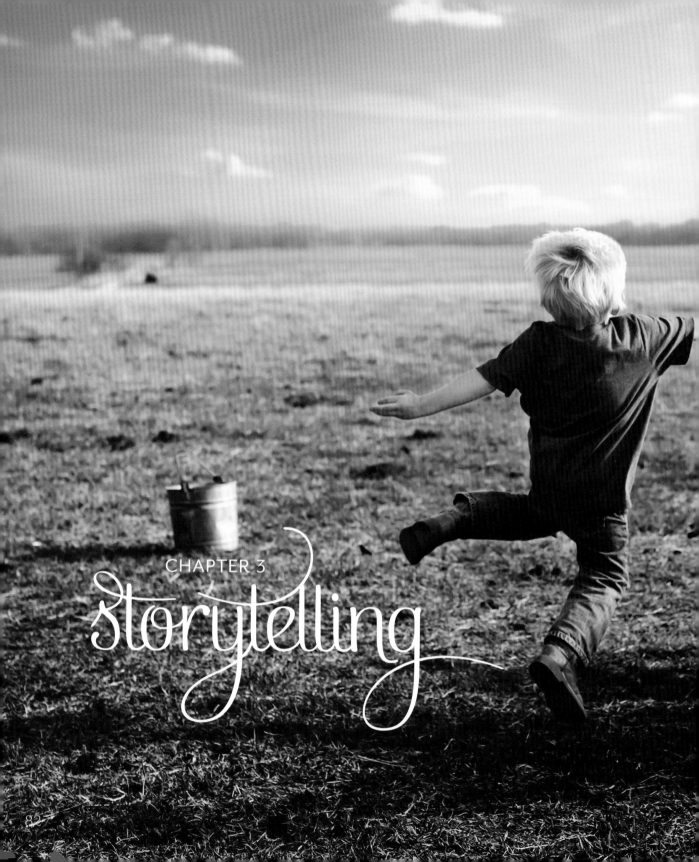

CHAPTER 3

storytelling

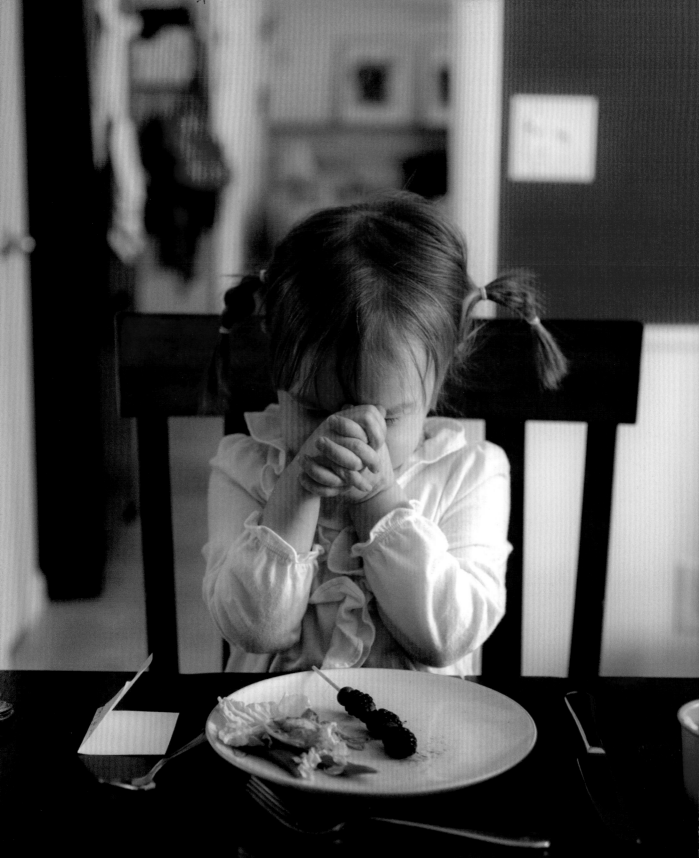

Visual storytelling comes in many forms, such as the photo essay, the storyboard, and the single frame. Whatever the final product, however, photographic stories are, at their core, not unlike traditional spoken or written storytelling. The building blocks are the same: setting, character, plot, theme, and voice. Approach your story as a narration with a visual vocabulary. Conceptualize—even outline—your story just as you would if you were preparing to put pen to paper.

find a great location

As with written works, setting is a fundamental element of your photographic story. Choose a location that enhances the mood of your story, tells the viewer something about your character, or provides cues about the events that are unfolding.

Shalonda Chaddock | CANON EOS 5D MARK III
50MM | ƒ/2.2 | 1/2000 SEC. | ISO 1600

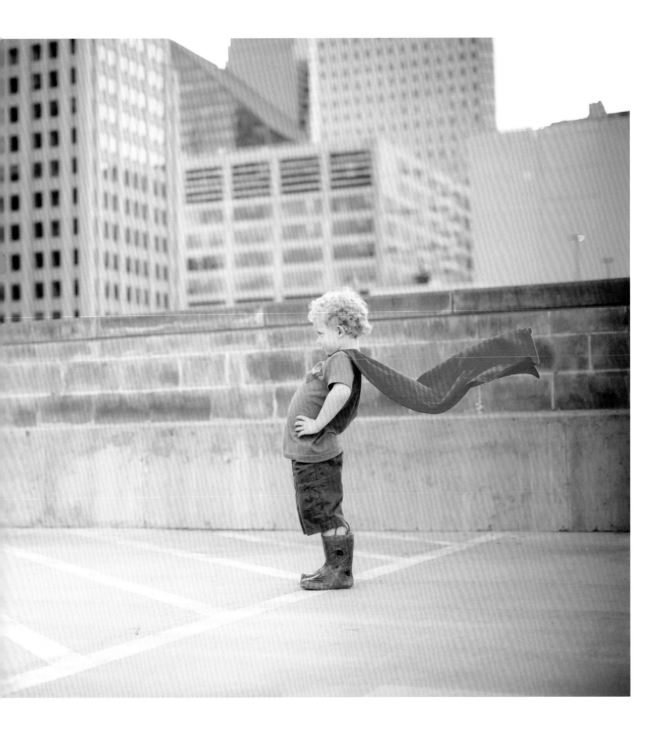

introduce your characters and establish connections

The story's characters may include one or more protagonists, antagonists, and supporting roles. Think about who you want to present and in what ways the audience should connect with them. Eye contact may help the viewer to feel like an active participant invested in the subject's fate. Physical perspective—seeing the world through the character's eyes or from a position of dominance or submission—will also affect the viewer's relationship with your subject.

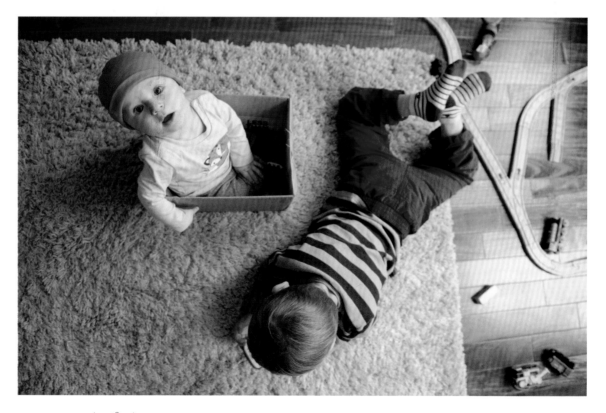

Jennifer James | NIKON D700 | 24MM | f/2.8 | 1/200 SEC. | ISO 1250

incorporate narrative conflict

Conflict drives the plot in photographic stories just as it does in written works. Are there clues in your frame as to the challenges characters may encounter, or is the conflict more overt? Consider ways in which you might present rising action, the story's climax, or the way things ultimately resolve.

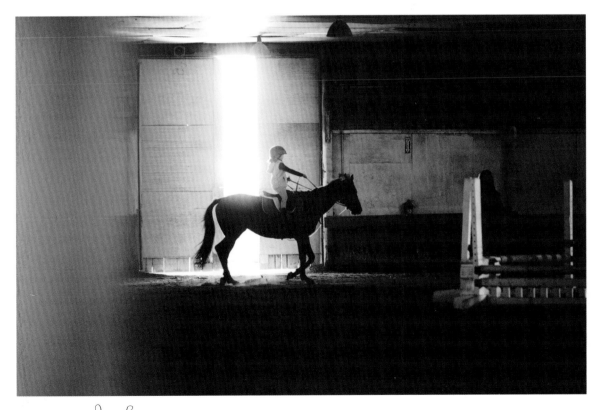

Kendra Okolita | CANON EOS 5D MARK III | 135 MM | *f*/2.2 | 1/250 SEC. | ISO 2000

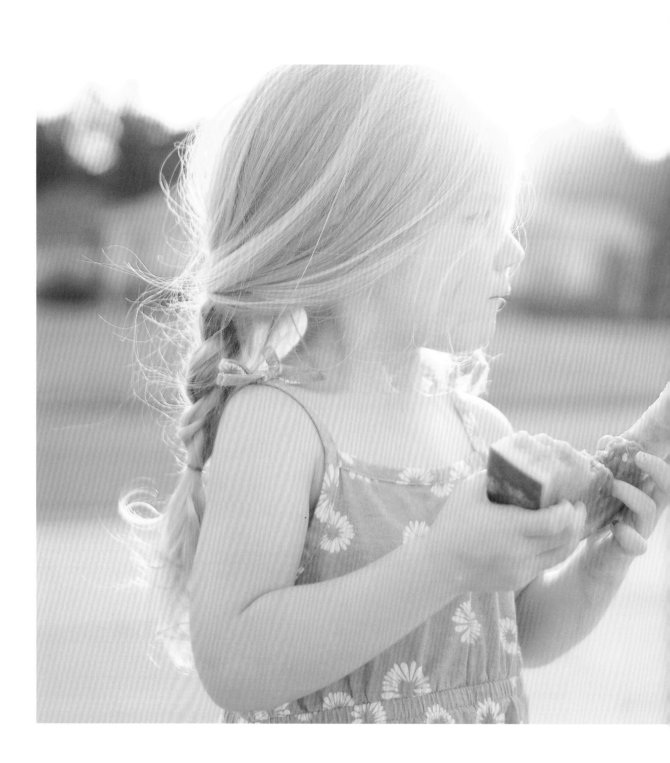

think about beginning, middle, and end

When visualizing your story, think about timeline progression. What aspects of the scene might help to illustrate the beginning, middle, and end of an action or event? For example, consider the preparation, presentation, consumption, and completion of a meal. Or photograph your child's day from the moment the alarm clock rings until you tuck her in at night.

Liz Behm | CANON EOS 7D | 30MM
f/1.4 | 1/3200 SEC. | ISO 160

develop themes for your narrative

Photographers utilize themes frequently, often subconsciously. Themes of innocence, imagination, and joy frequently characterize children's portrait sessions; love, spirituality, family, and coming of age guide wedding photographers thematically. Describe, in just a few words, the theme of your story, and evaluate how each element within the frame resonates with your underlying theme.

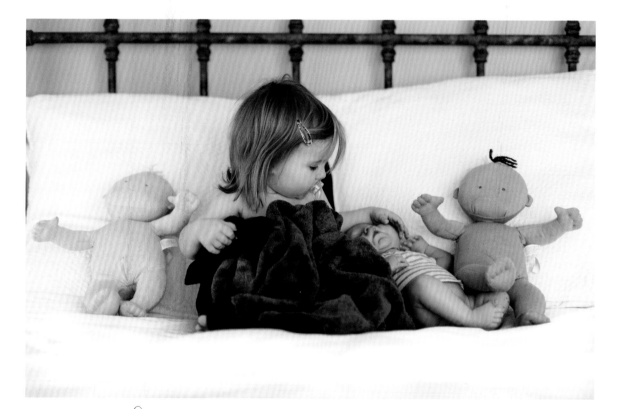

Anna Christine Larson | CANON EOS 5D MARK II | 50MM | ƒ/2.5 | 1/100 SEC. | ISO 640

prioritize the light

If you apply only one piece of advice to all of your shooting, make it this: light first, subject second. Seek out interesting lighting, and then place your subject in it, wait for a subject to enter the scene, or search for an interesting story in or around that lighting.

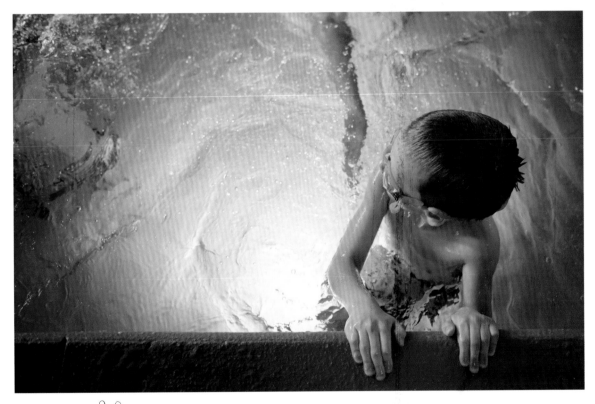

Meredith Novario | NIKON D700 | 32MM | ƒ/2.8 | 1/250 SEC. | ISO 1600

establish your settings

Select your white balance and exposure ahead of time, taking test shots to ensure perfect settings before the action even commences. Once your characters arrive on the scene and the action begins to unfold, you'll be able to react quickly to the moments underway.

Sarah Morris | NIKON D3 | 35MM
f/1.4 | 1/125 SEC. | ISO 2200

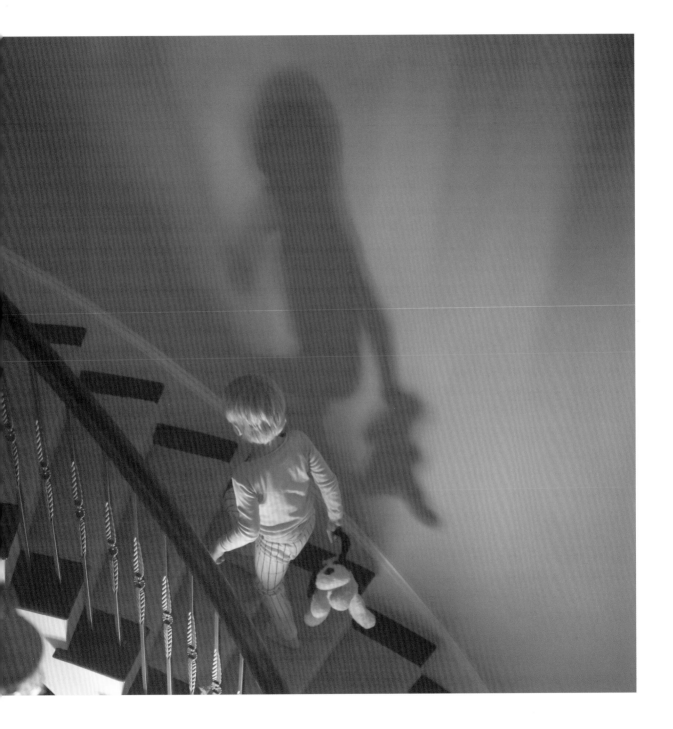

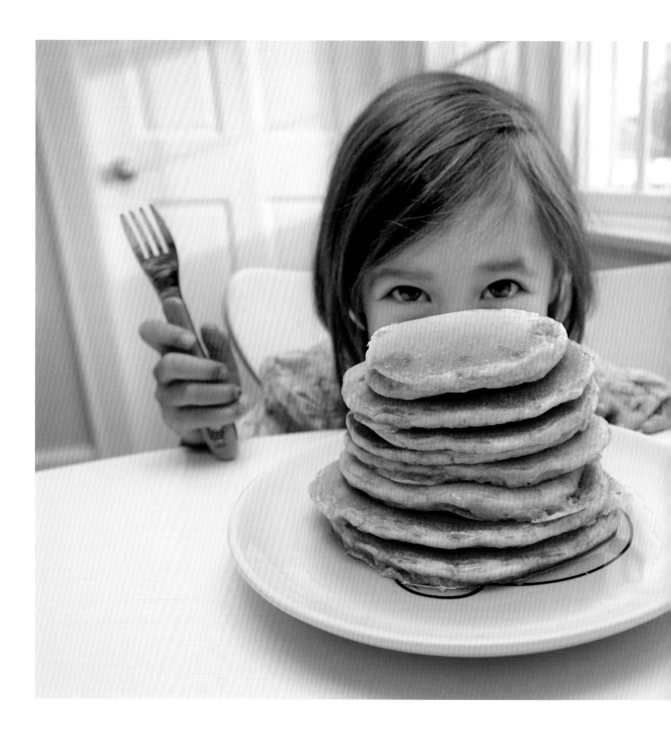

previsualize compositions

Examine your scene for distractions, clean up clutter, and don't be afraid to move furniture in the room if needed. Think of yourself as a set designer. If you were setting up a scene in the kitchen, would there be dirty dishes in the sink? Twelve appliances on the counter? An overflowing trash can? School calendar on the fridge? Only you can answer these questions. It's your story. If you want it there, don't let anyone tell you that it doesn't belong.

Alix Martinez | CANON EOS 5D MARK II | 19MM
f/5.0 | 1/160 SEC. | ISO 800

be patient but open-minded

Have a clear idea of what you want to capture, prepare for it as much as you can, and wait for the moment to materialize in the frame. Keep in mind, however, that while it's helpful to have a final vision in your head, you should also allow yourself to recognize unexpected opportunities. Sometimes the plot twists yield something even better than you might have imagined.

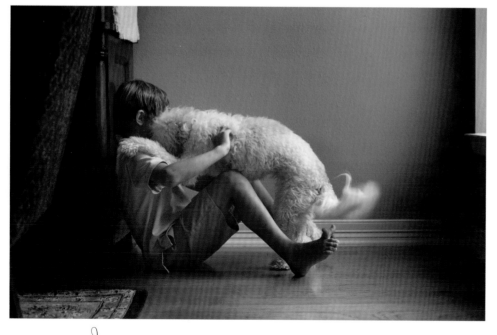

Jodi Arego | NIKON D700 | 50MM | *f*/2.8 | 1/60 SEC. | ISO 320

keep both eyes open

Do you squint when shooting? Try keeping both eyes open as you observe the story unfolding in front of you. Scan the scene for details or distractions in order to determine what to include in or exclude from the frame.

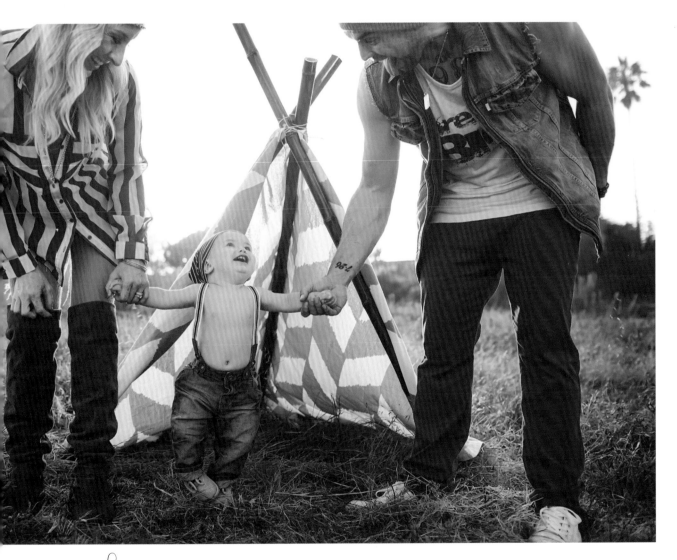

Tarah Sweeney | CANON EOS 5D MARK III | 35MM | ƒ/2.5 | 1/2500 SEC. | ISO 400

shoot momentous events and milestones

Childhood firsts, travels, celebrations, and holiday traditions represent some of the most important moments by which we document the passage of time and our life stories. Be sure to incorporate shots from attendees' points of view. These photographs will most effectively conjure up memories of the event just as they experienced it.

Christina McGuire | NIKON D700 | 28MM
f/2.8 | 1/60 SEC. | ISO 1250

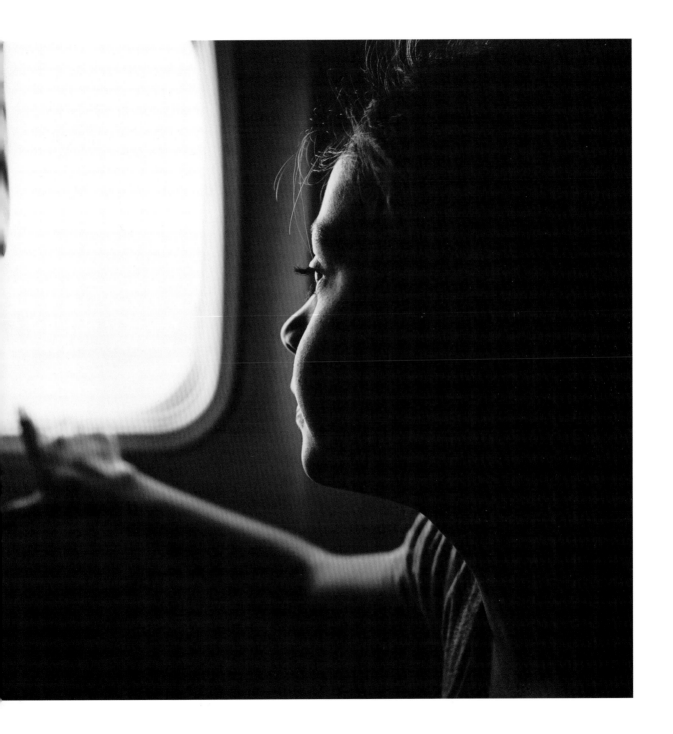

capture everyday magic

Most of us do a great job of documenting extraordinary outings, celebrations, and milestones, forgetting that many of our most cherished memories are derived from everyday moments. It can be difficult to step back and appreciate the beauty of life as we experience or observe it day in and day out, but the fact is that our daily activities do change—sometimes incrementally and imperceptibly. The rituals and routines that we so often take for granted are gone before we know it.

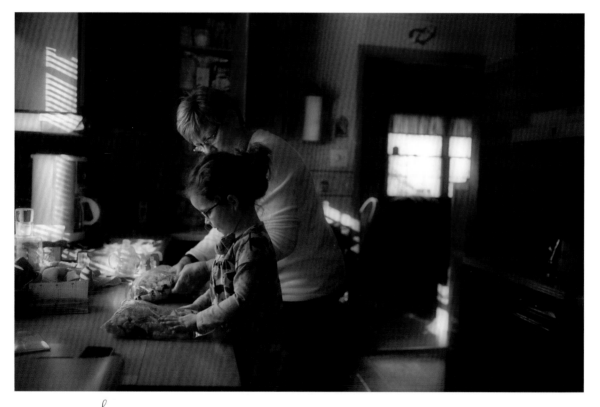

Melissa Stottmann | NIKON D700 | 35MM | *f*/2.5 | 1/125 SEC. | ISO 200

provide a sense of time and place

Portraying the season, location, or era of a photograph greatly strengthens an image's documentary significance. Elements such as technology, wardrobe, and signage can provide cues as to the time and place of the story you're capturing.

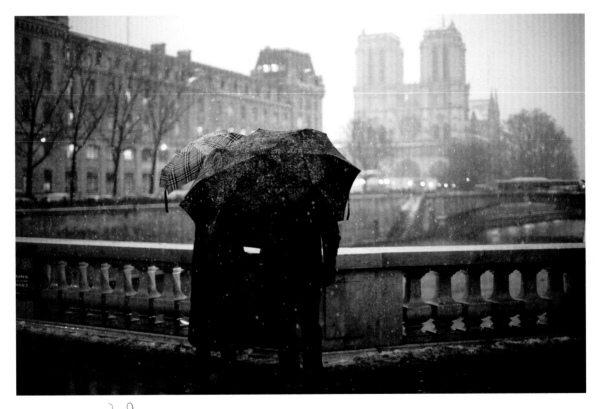

Juliette Fradin | CANON EOS 5D MARK II | 50MM | ƒ/1.4 | 1/160 SEC. | ISO 1250

pay attention to the details

Get beyond the action and come in close to capture the small details that round out your story. Think about the physical details a novelist might include in describing your character (the way hair tendrils curl around the ear, the scar across the forehead, the needlework of the dress) or in setting the stage for the scene (the green leaves just beginning to curl as fall approaches, the perfectly arranged china figurines in the cabinet, or the aged wood of the winding staircase).

Shalonda Chaddock | CANON EOS 5D MARK III
85MM | f/1.4 | 1/1600 SEC. | ISO 250

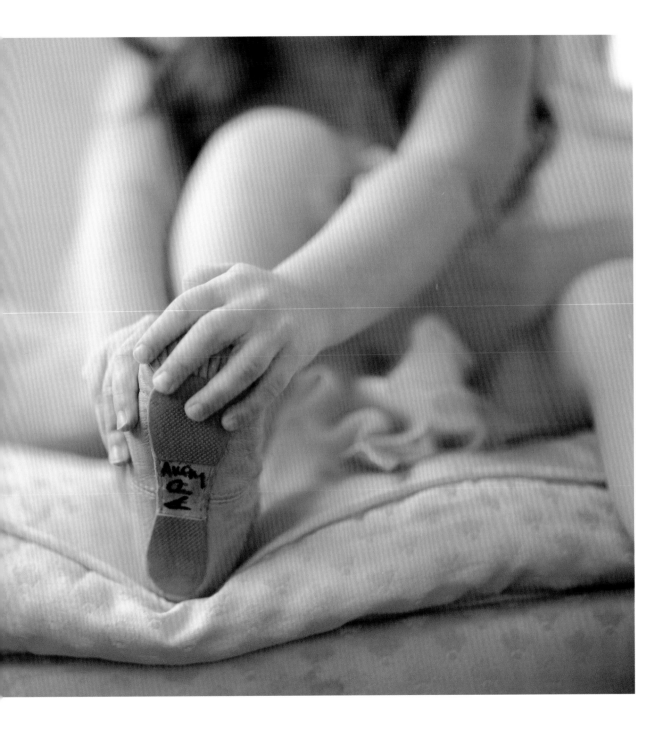

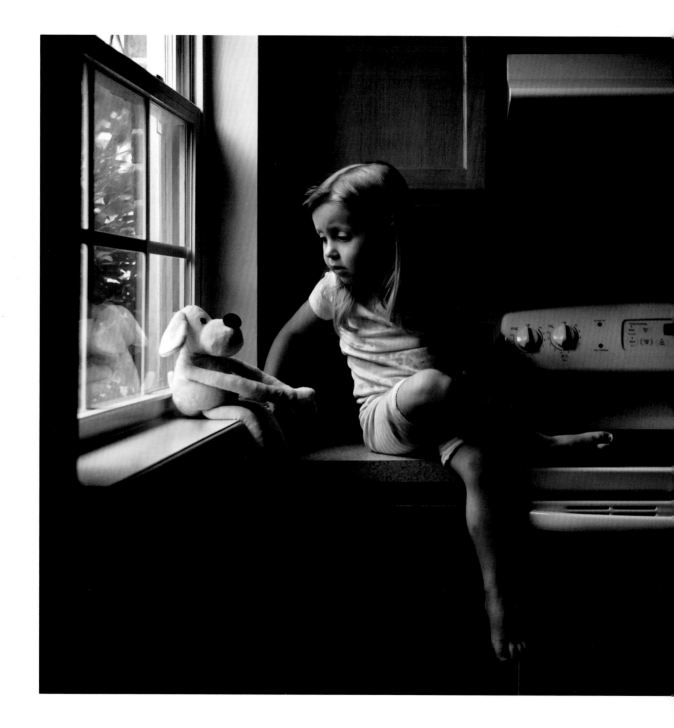

study body language

Body language often conveys true feelings more faithfully than facial expressions. How can you capture joy without seeing a smile, sadness without including the tears, uncertainty without the furrowed brow? Studying body language can help you to identify authentic moments and create more nuanced stories within the frame.

Allison McSorley | NIKON D700 | 28MM
f/2.5 | 1/250 SEC. | ISO 1600

focus on relationships

The interactions between your characters and the connections they share often provide the groundwork for a story. Are your characters friends? Lovers? Enemies? Family? Strangers? Whatever the relationship, a physical touch, a shared experience, or even simple eye contact can mark the beginning (or end) of a story.

Tiffany Bender | NIKON D700 | 70MM | f/2.8 | 1/250 SEC. | ISO 400

go beyond the sense of sight

Although photography is a visual medium, you can tell a richer and more robust story by striving to represent other sensory experiences with your images. Let your photographs describe smell, touch, taste, and sound just as writers capture these senses with their words. Draw your viewer into the moment by illustrating the temperature or textures that we associate with touch, incorporate movement or expressions that call to mind infectious laughter or voices in harmony, or appeal to the tastes and smells of a culinary moment.

Liza Hall | NIKON D700 | 50MM | f/2.5 | 1/500 SEC. | ISO 800

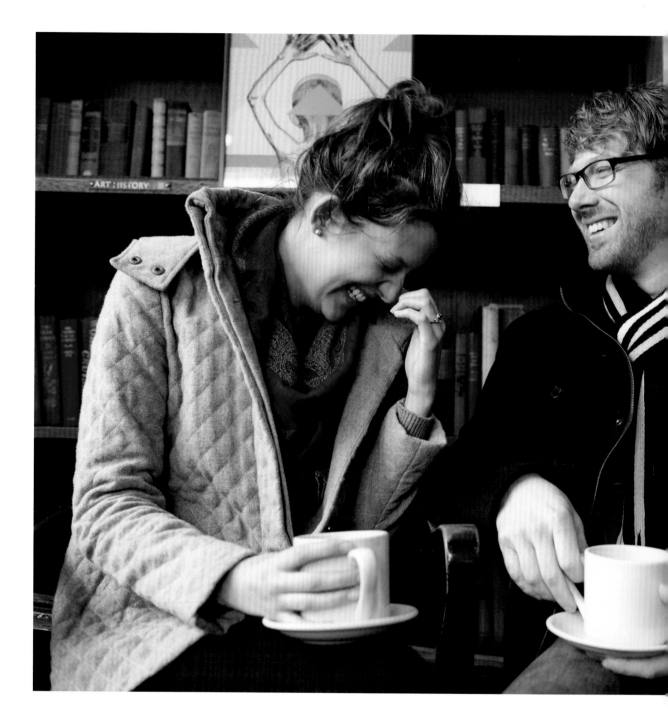

anticipate emotion

Rather than asking subjects to smile for the camera, learn to anticipate genuine emotion, watching for laughter to bubble over during conversation, delight during gameplay, or surprise in an unexpected turn of events.

Bre Thurston | CANON EOS 5D MARK III | 35MM
f/2.8 | 1/125 SEC. | ISO 2000

remember that happiness isn't the only emotion worth capturing

Sadness, pain, grief, anger, and disappointment are just some of the many emotions from which photographers often shy away, preferring only to capture the joys of life. Capture the authenticity of the human experience by embracing a full range of emotions when you shoot.

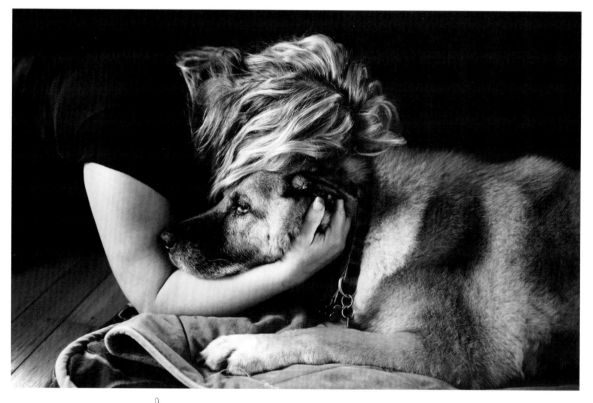

Corinne McCombs | CANON EOS 5D MARK III | 35MM | f/2.0 | 1/200 SEC. | ISO 2000

become part of your own story

Point of view is a fundamental storytelling element, and the first-person perspective in art is often underutilized. Set up a tripod, hand off your camera, or grab a wide-angle lens and shoot from your own perspective, with your arms or legs in view.

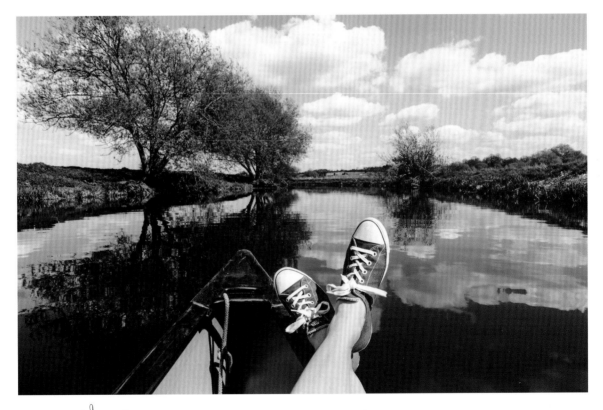

Rebecca Spencer | NIKON D700 | 24MM | *f*/14 | 1/200 SEC. | ISO 200

remove faces for universal appeal

A creative crop, use of shadow, or change in perspective that obscures the face or removes the head from the frame adds a layer of anonymity to your photography. When a subject is personally unidentifiable, the viewer can impart to the figure an imagined identity with which he or she is more likely to relate.

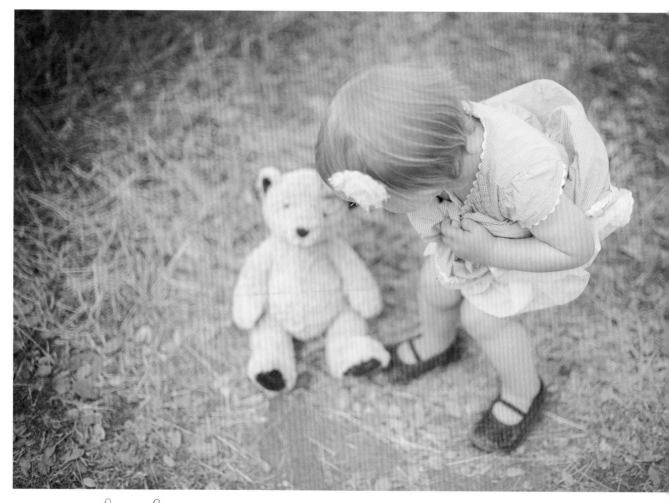

Heather Lazark | CANON EOS 5D | 50MM | *f*/1.8 | 1/320 SEC. | ISO 500

get up close and personal

Get in close to the action or moment underway. Crouch down at the finish line as the winning runner's feet sprint across, zoom in tight from behind to share the subject's viewpoint, or use a macro lens and come within inches of the subject.

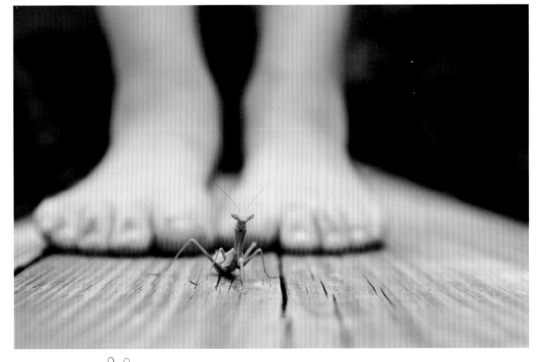

Meredith Novario | NIKON D700 | 52MM | *f*/3.5 | 1/1000 SEC. | ISO 400

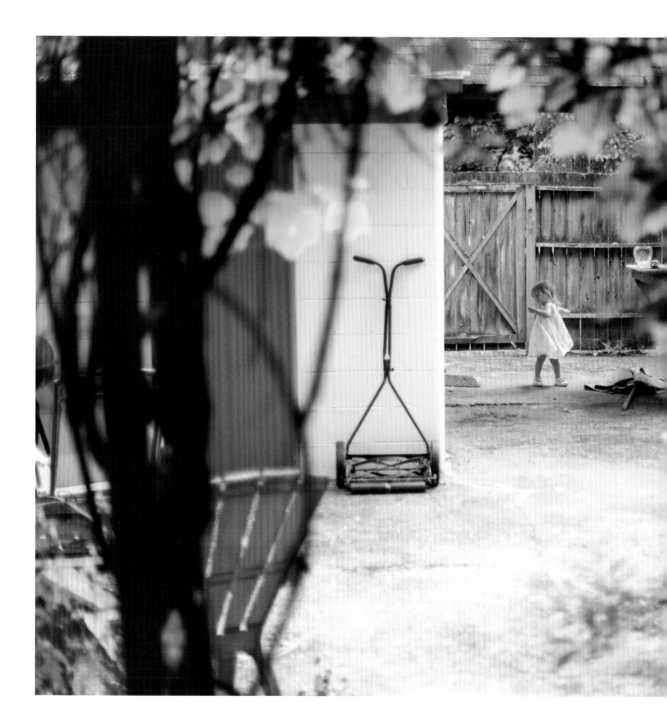

shoot from the sidelines

Awareness of a camera can cause subjects to act unnaturally. Find an inconspicuous position from which you can shoot unnoticed. Use foreground elements such as the branches of bushes, a gap in a fence, the edge of the window frame, or a crack in the doorway to create a strong sense of the outsider looking in.

Elena Blair | CANON EOS 5D MARK II | 50MM f/1.4 | 1/2500 SEC. | ISO 40

identify visual echoes

Pay attention to repeating elements within the frame that reinforce or elevate the story. Look for visual repetition among subjects engaged in the same or similar activities, such as a child emulating her mother.

Adele Humphries | CANON EOS 5D MARK II
35MM | f/2.2 | 1/160 SEC. | ISO 6400

watch for opportunities to frame a story within a story

The main story typically revolves around the activity of the primary subject, but a secondary story may emerge in the way others observe that activity, in a separate background event, or in an impending disruption.

Amelia Soper | CANON EOS 5D MARK II | 35MM | *f*/4.0 | 1/125 SEC. | ISO 2500

capture a visual epilogue

After the story concludes and the characters leave the scene, take a moment to shoot what's left behind. Your epilogue might include handprints on the window, footprints in the snow, crumpled gift wrap, a half-eaten slice of cake, or rumpled bed sheets.

Tami Wilson | CANON EOS 5D MARK III | 50MM | *f*/1.4 | 1/200 SEC. | ISO 320

storytelling

CREATIVITY EXERCISES

photograph your visual autobiography

Forever behind the camera, photographers are often conspicuously absent from photographs. It's important to capture your own story, and part of that requires you to get in the frame. Try shooting from the first-person perspective, incorporating some part of your body—arms, legs, hands, feet—in your image. Make viewers feel like they're stepping into the proverbial shoes of the person behind the camera, and carefully incorporate contextual elements to illustrate setting, activity, or a personal connection. Alternatively, choose a meaningful third-party point of view, such as that of a child. Set your tripod up to approximate the same height as one of your children and place it on the edge of your scene, perhaps even using foreground framing to help draw the eye in. Prefocus, and use your camera's timer, remote, or intervalometer to shoot your world—and yourself—from the hypothetical child's perspective.

build your story around words

Text within the frame is powerful, and you can incorporate words visually to advance your story or convey insight into your character. For example, might you include the family name on a mailbox, the Big Brother designation on a child's T-shirt, or the pregnant woman next to the Bump Ahead sign? Or perhaps the text itself is the story: a child's mischievous wall graffiti, a lipstick love note on the bathroom mirror, or a teacher's writing on a chalkboard. Can you photograph a subject reading a newspaper headline around which you build the story in the frame? Can you incorporate the Quiet sign at a library or the word Hot on a billboard to reinforce story or for ironic effect? Including common notice or warning signs—such as One Way, Stop, Do Not Enter, Condemned, Caution, or Dead End—is also a great way to express thematic or narrative messages.

shoot from behind

Rather than photographing a story directly as it unfolds, draw back and bring an observer into the foreground as a secondary subject. Shoot from behind the observer's back so that the viewer can empathize with him, watching the main scene from his point of view. Does the observer seem to have a relationship with the primary subject or subjects? Is he involved or invested in the action? Is he a neutral bystander? How does the feeling change if you are immediately behind the observer as opposed to pulled back significantly? Allow the scene to become not only about the primary story but also about the way this additional observer experiences or watches it from the sidelines.

tell an unspoken story

The human face provides the most obvious cues to happiness, anger, sadness, surprise, impatience, and other emotional states, so it should be no surprise that photographers tend to focus on facial expression—with particular emphasis on the eyes and mouth—in portraiture. As students of human emotion know, however, body language such as posture, position of limbs, use of hands, and angle of the head often convey far more authentic feelings. Studying body language can be very helpful not only in broadening your approach to portrait photography but in being more effective in your photographic storytelling, establishing mood, and heightening your own awareness of the way that your audience is likely to perceive your photograph. For this exercise, photograph a portrait that excludes the subject's face. That may involve shooting the subject from the back, cropping below the neck, or photographing a figure engulfed in shadow or blocked by other elements. Rely on the language of the body itself to convey universal feeling and emotion.

record the aftermath

Explore your home or another setting looking for evidence of a visual epilogue. What clues can you find about the characters who have departed the scene and the plot that must have unfolded? Photograph the remnants that remain, incorporating as many details as you can to help your viewer imagine or piece together the story, scene, and characters.

CHAPTER 4

fine art

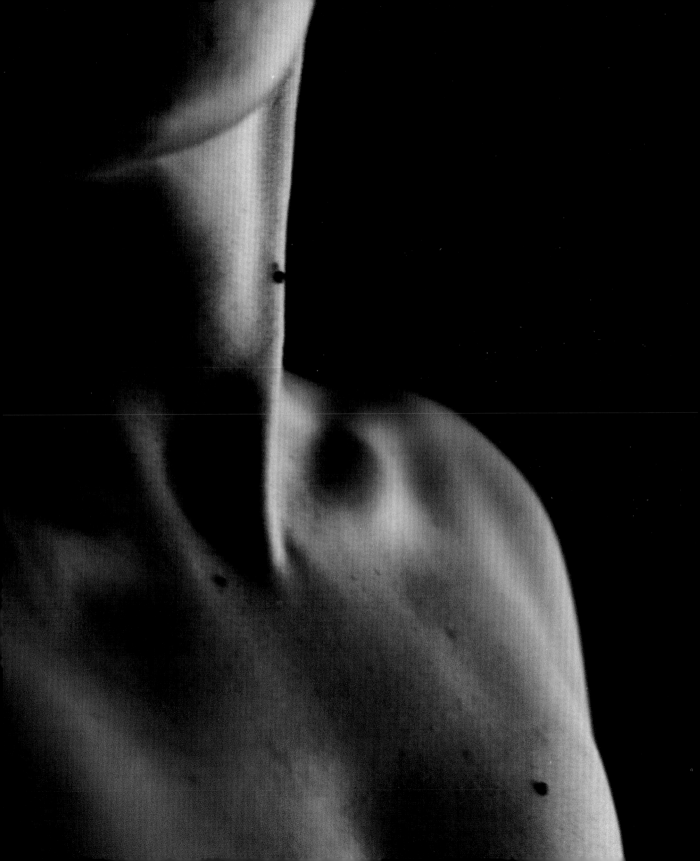

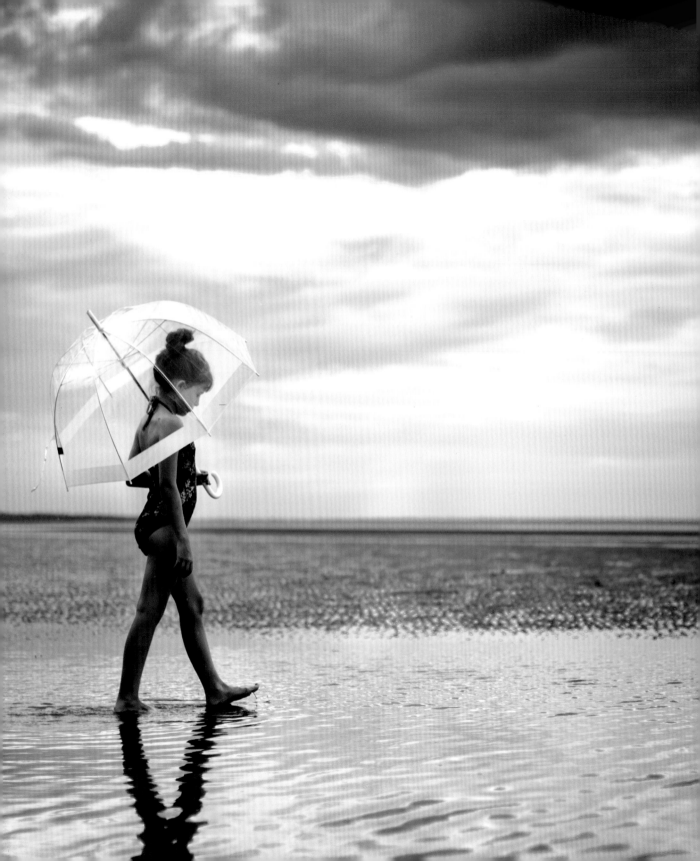

Defining "art" is a challenge that will likely never have a universal resolution. In this chapter, we'll explore fine art photography as an approach distinct from photography that primarily serves documentary, commercial, or functional purposes. Instead, fine art photography is an expression of the photographer's aesthetics, emotion, imagination, or intellect. As a photographer expresses her unique creative vision or message, the resulting work may also push the boundaries of standard principles, techniques, or subject matter.

channel the old masters

Studying iconic master painters—from Leonardo da Vinci to Rembrandt van Rijn to James McNeill Whistler to Andrew Wyeth—is an excellent way to train your eye and inspire your photography. Examine the way these artists constructed their compositions on the canvas, utilized light and shadow, controlled color palettes, or gravitated toward particular subjects or settings.

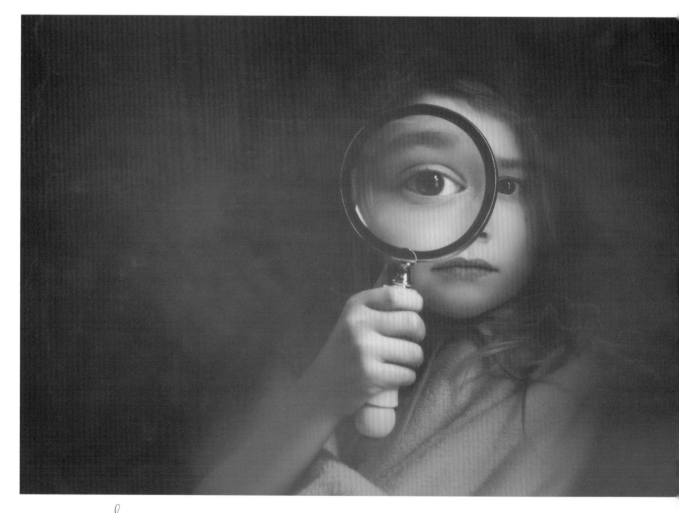

Caroline Jensen | CANON EOS 5D MARK II | LENSBABY EDGE 80 OPTIC | f/2.8 | 1/125 SEC. | ISO 6400

shoot metaphorically

Develop a concept or message that you would like to capture; then think about objects that embody this concept or message in some way. It may help to study symbolism and archetypes, but also explore objects that are personally meaningful to you, such as those that represent yourself or another person, commemorate a moment in time, or elicit particular emotions.

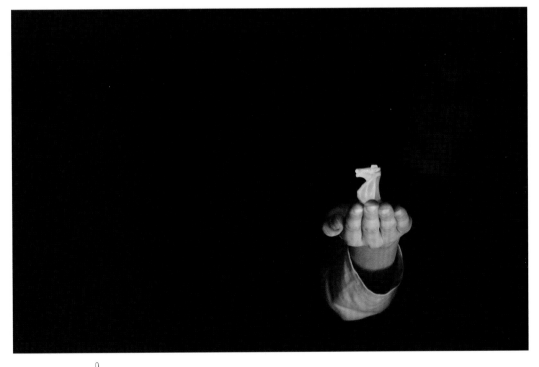

Sabra McKibben | CANON EOS REBEL XS | 50MM | *f*/1.8 | 1/125 SEC. | ISO 100

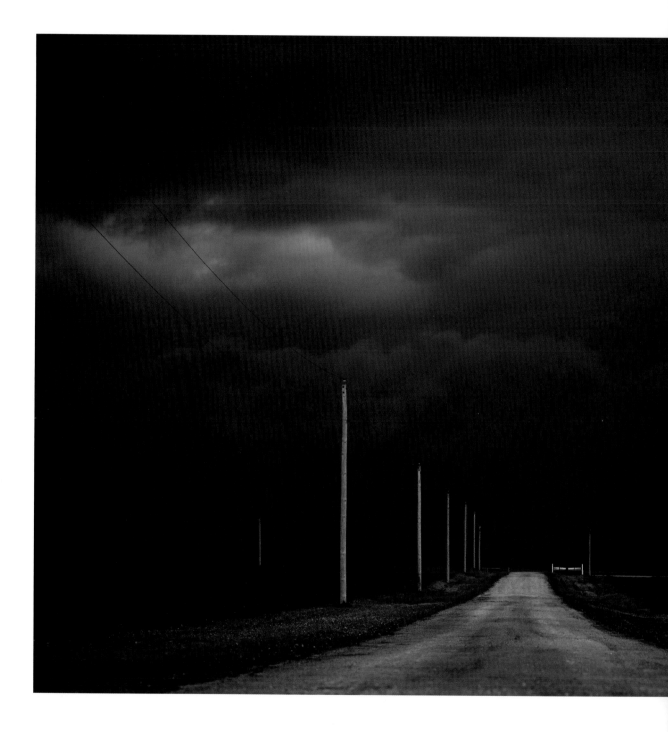

deconstruct your subject into design elements

Imagine a simplified version of your subject and scene much as a child might illustrate it. Envision these components as an arrangement of lines and shapes, and balance the elements within the frame.

Amber Schneider | NIKON D600 | 85MM
f/2.8 | 1/400 SEC. | ISO 400

find nontraditional beauty

Identify the potential for an ordinary object
to become something extraordinary within
the viewfinder. Photograph a subject or scene
traditionally considered ugly, unappealing,
undesirable, or even downright repulsive.
Forget the associations you have with this
subject, and instead analyze it visually,
exploring its shapes, lines, textures,
and the way light and shadow play upon it.

Alicia Gould | CANON EOS 5D MARK II | 45MM
ƒ/2.8 | 1/80 SEC. | ISO 3200

photograph your subject indirectly

Shadows and reflections represent the presence of the physical subject. Rather than photographing the subject directly, shoot the surface on which its shadow is cast or on which its reflection appears. Consider, too, the ways in which indirect shooting may introduce distortion or render the subject personally unidentifiable.

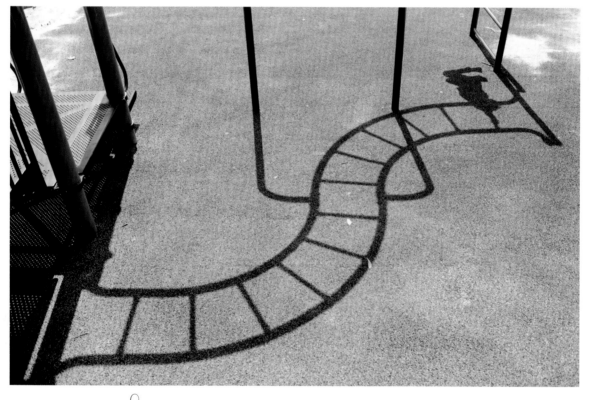

Tracy Lauthere | NIKON D700 | 35MM | *f*/4.5 | 1/800 SEC. | ISO 200

impart life to nonliving things

Photograph inanimate objects or events as if they possess a story to tell, have an emotion to convey, or otherwise project some human qualities. Focus on whether you can suggest that your nonhuman subject has feelings, intent, or even human physical characteristics.

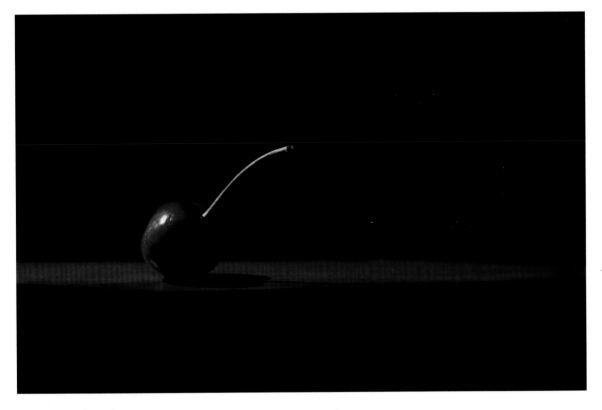

Jenni Jones | NIKON D700 | 50MM | *f*/3.2 | 1/400 SEC. | ISO 320

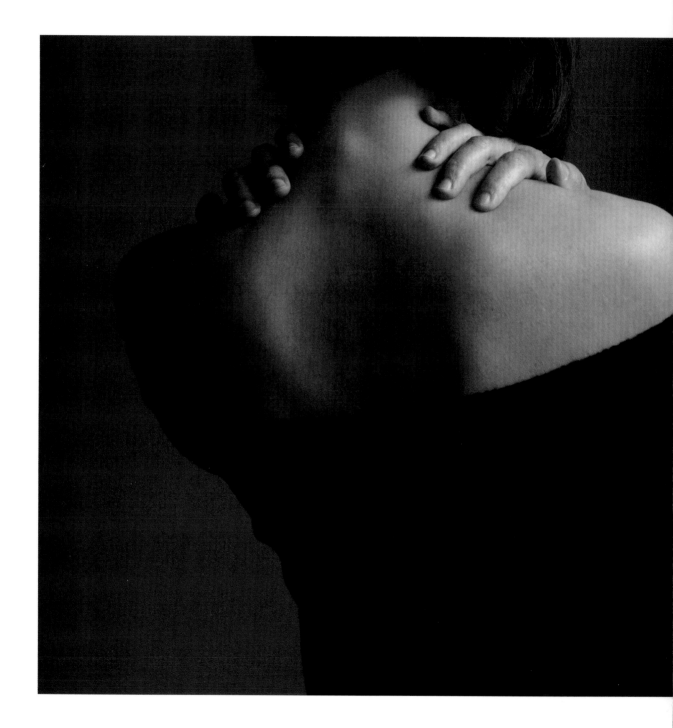

use photography to explore and express your own emotions

Photography is an extraordinary outlet for expression in each stage of creation. Creative conceptualization, the physical act of shooting, and finalization of vision can all be therapeutic processes. Feeling lonely? Serene? Overwhelmed? Triumphant? How can you express those feelings visually?

Megan Dill | CANON EOS 5D MARK III | 100MM
f/7.1 | 1/125 SEC. | ISO 5000

incorporate conceptual opposites

An image can illustrate captivating tension by incorporating elements in opposition. Visual opposites are simple but effective: big versus small, one versus many, or dark versus light. Opposing pairings can also represent concepts (wealth versus poverty, before versus after, order versus chaos) or literary conflicts, such as man versus society or man versus nature (shown here).

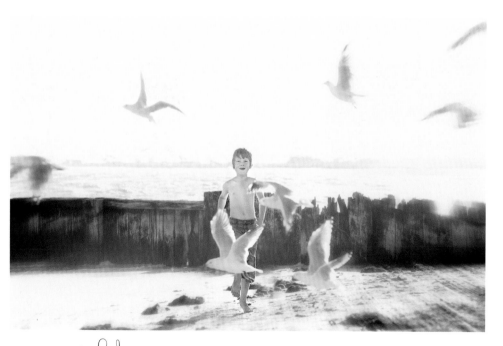

Leah Robinson | CANON EOS 5D MARK II | 135MM | *f*/5.0 | 1/640 SEC. | ISO 200

juxtapose unexpected elements

Simply removing an element from its conventional context or placing two dissimilar subjects together adds a layer of interest. The effect may be ironic, humorous, or intriguing.

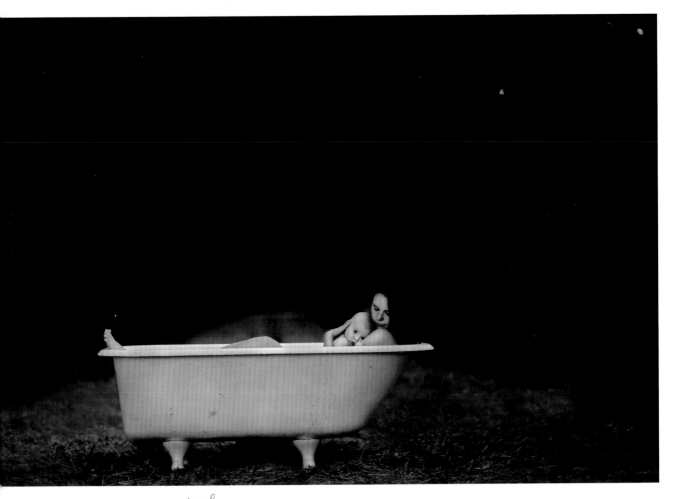

Megan Axelsson | NIKON D700 | 85MM | f/1.4 | 1/320 SEC. | ISO 200

defocus your lens

Throwing your lens out of focus is a
wonderful way to achieve a dreamy,
ambiguous effect. Set your focus to
manual and rotate the focus ring
to see how varying levels of softness
establish different creative effects.

Megan Dill | CANON EOS 5D MARK II | 35MM
f/2.2 | 1/400 SEC. | ISO 200

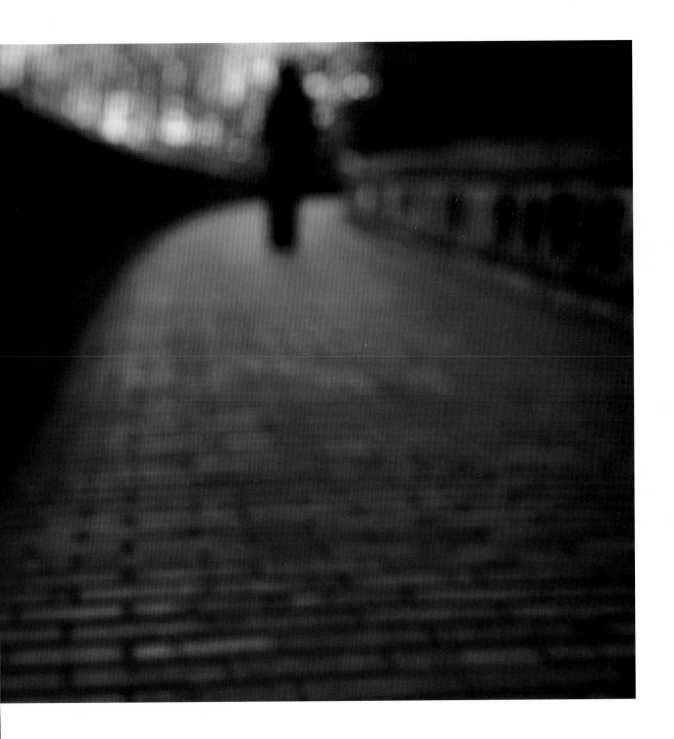

embrace the
abstract

Abstraction in art has been utilized for centuries. In photography, defocusing, motion blur, and extreme close-ups all yield abstract effects.

Danielle McIlroy | NIKON D3100 | 60MM
f/3.8 | 1/250 SEC. | ISO 100

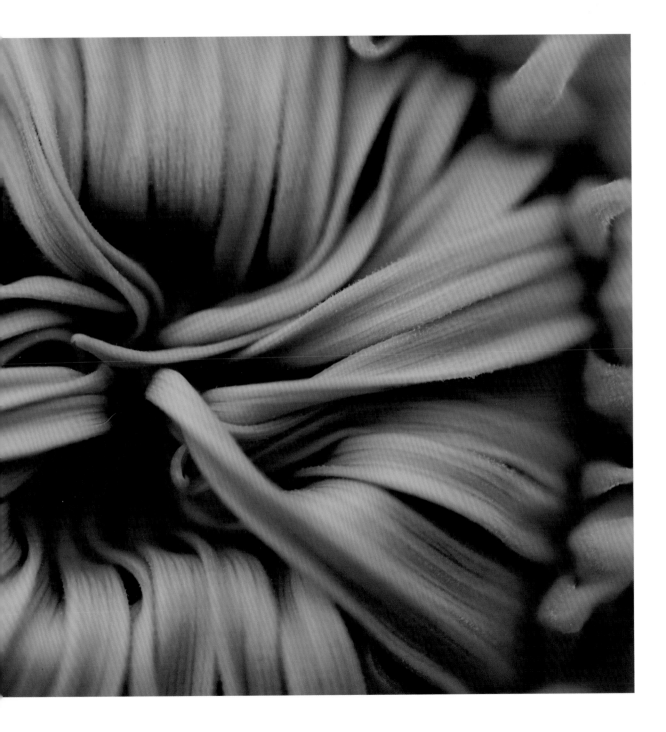

shoot from unusual positions

Become adventurous in your positioning in order to capture perspectives others are unlikely to have seen. Lie flat on your back and shoot upward, obtain a waterproof camera housing and take your camera right into the bathtub or lake, gain aerial perspective from a helicopter or a fiftieth story balcony, or place your camera inside your refrigerator or dryer and shoot from the viewpoint of the contents therein.

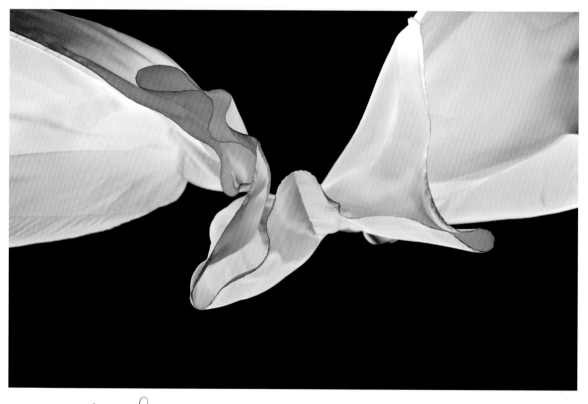

Justine Knight | NIKON D90 | 35MM | *f*/2.8 | 1/320 SEC. | ISO 800

convert a powerfully colorful subject to black and white

Converting a subject that we strongly associate with color—such as flowers—to black and white can be very striking. This unexpected choice disrupts our perception of the subject and allows us to explore facets of it that we almost certainly overlooked previously.

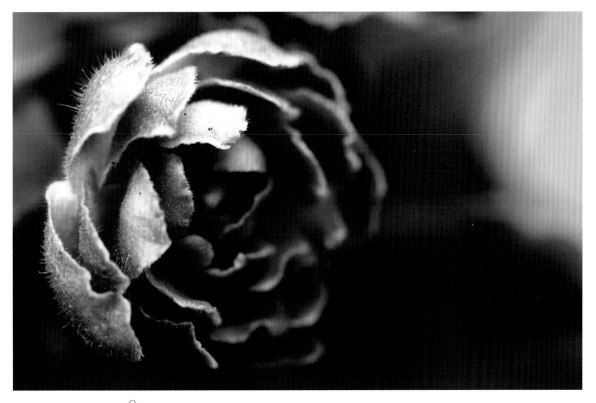

Monica Wilkinson | NIKON D700 | 105MM | *f*/11 | 1/100 SEC. | ISO 3200

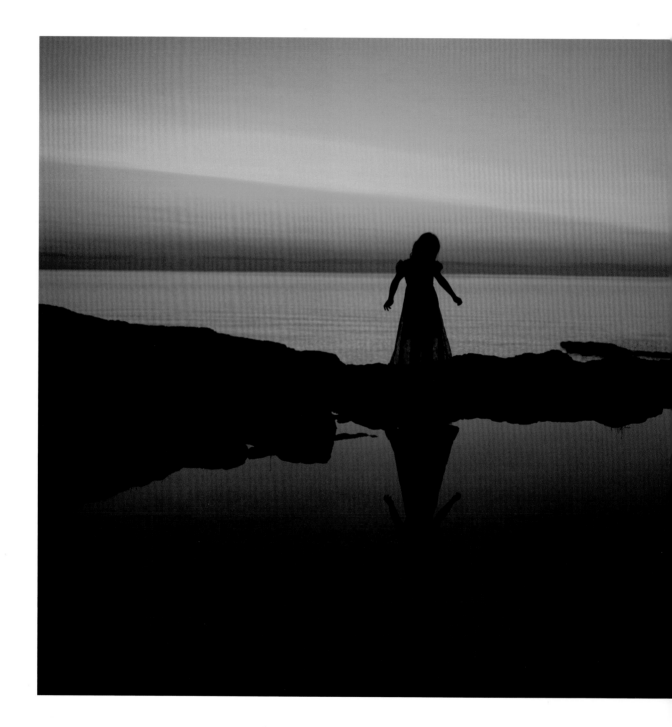

match the lighting to the mood you want to convey

The color and quality of light affect not only the general beauty of the image but also atmosphere and even genre. What light best tells your story? Warm and dreamy filtered light? Dramatically deep tones of dusk? Cool and clinical light from fluorescent lamps overhead?

Amy Lucy Lockheart | NIKON D4 | 35MM
f/2.2 | 1/250 SEC. | ISO 100

experiment with white balance

Clean, neutral white balance illustrates the world as viewers naturally perceive it. Push your color creatively, either by selecting creative white balance settings in camera or adjusting color temperature and tones in post-processing. Green undertones can connote sickness or supernatural qualities, warm tones work well for cheerful nostalgia, and cool tones might suggest serenity or physical frigidity.

Liza Hall | NIKON D700 | 50MM | *f*/2.2 | 1/640 SEC. | ISO 200

mix techniques from alternative genres

Try utilizing high ISO in brightly lit settings, shooting portraits at *f*/22, or using optics in nontraditional ways, such as tilt-shift photojournalism or ultrawide-angle still life. This image, for example, employs a wide-angle tilt-shift lens, traditionally used for architectural photography, in an environmental portrait for an unusual and striking effect.

Lissa Chandler | CANON EOS 5D MARK II | 24MM | *f*/3.5 | 1/60 SEC. | ISO 1600

incorporate elements of anonymity

A human face in the frame invariably commands the viewer's attention. By removing the face, other elements draw the eye and become much more instrumental in communicating a more universal story or message.

Lisa Benemelis | CANON EOS 5D MARK III
135MM | *f*/2.2 | 1/1000 SEC. | ISO 100

photograph the edges of life

Most recognize the beauty in impending birth and new life, but subjects (both living and still life) in a state of degeneration, decay, or ruin can be equally compelling. Peeling paint, crumbling rock, weathered skin, rusting metal, and the shriveling edges of petals or foliage are all rich in texture and may have wonderful stories to tell.

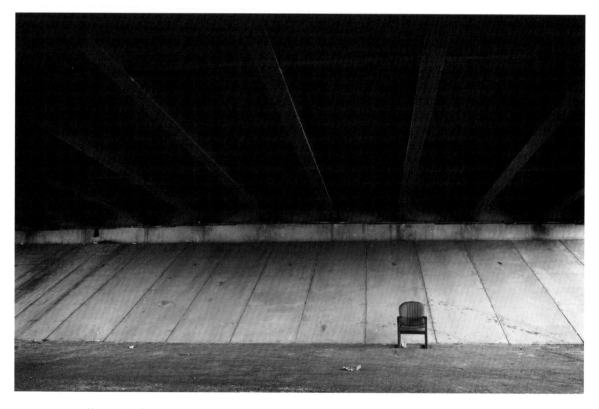

Megan Axelsson | NIKON D3 | 35MM | *f*/4.0 | 1/250 SEC. | ISO 560

remove or obscure a critical element

Obscuring an important subject or critical aspect of that subject creates tension and mystery for viewers. Try composing your frame with walls blocking part of the scene, a hand in front of the face, fog or shadows obscuring an approaching subject, or a supplemental element just beyond the edge of the frame.

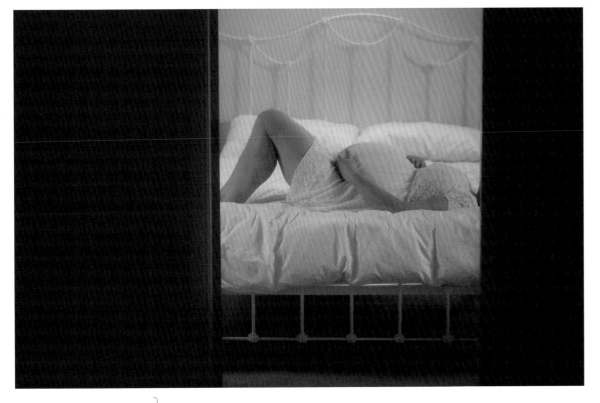

Katrina Stewart | CANON EOS 5D MARK III | 100MM | *f*/2.8 | 1/60 SEC. | ISO 2500

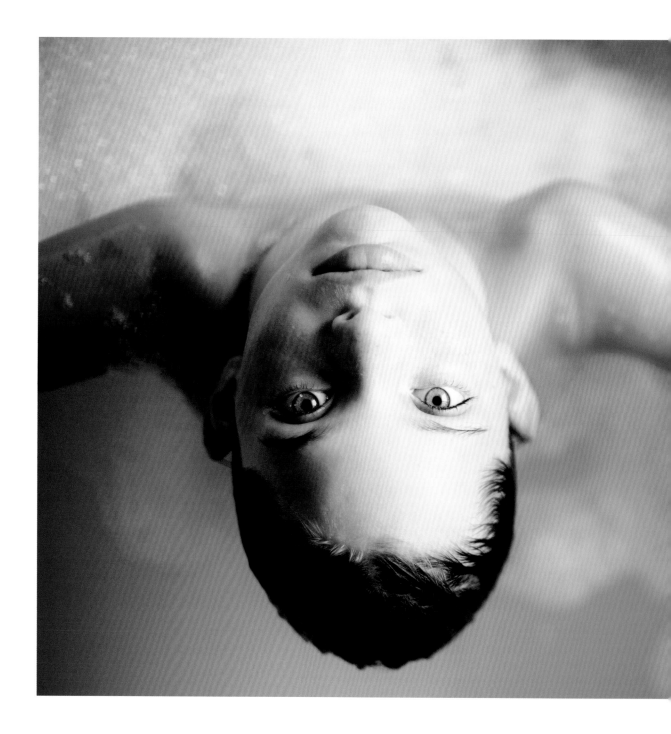

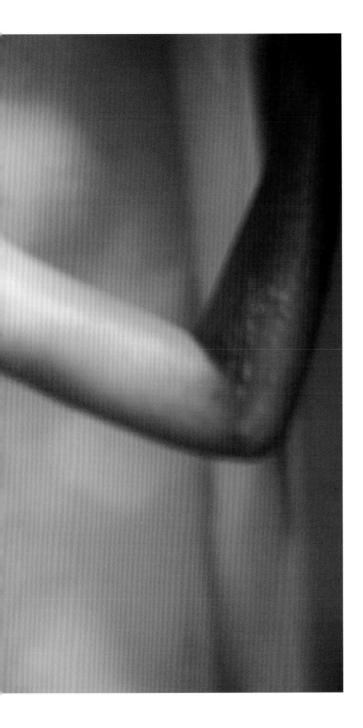

utilize chromatic association

Fine artists and film directors use chromatic repetition to create a visual association among elements or scenes. The repetition of one or more distinct colors throughout the frame establishes a psychological connection among the elements that incorporate them.

Monica Wilkinson | NIKON D700 | 50MM
f/1.6 | 1/500 SEC. | ISO 500

consider the psychological effects of color

Color is effective in helping to set the mood of your image. Generally speaking, dull colors produce a subdued effect, whereas highly saturated colors convey energy. Various colors connote different concepts and emotions, from the enlightenment or joy of yellow to the serenity or coolness of blue.

Melissa Gibson | NIKON D700 | 35MM
f/1.4 | 1/400 SEC. | ISO 400

fine art

CREATIVITY EXERCISES

draw inspiration from a dream journal

Keep a dream journal by your bed at night, and record whatever you can remember of your dreams immediately upon waking each day. Write in stream of consciousness, assemble a simple word list, or even sketch out visual representations of your experience. Think not only about what happened in your dream but also the feelings, colors, and sensory experiences involved. Consistent practice of this exercise will improve the lucidity of your dreams and the amount and detail of your dream recall. Regularly refer to your dream journal, and conceptualize photographs based on the notes or word lists you've recorded.

study the finest color palettes in history

The deliberate selection of palette and mixing of colors not only gives painters complete control over the mood and symbolic effects of the

they use, but it also helps to establish a readily identifiable artistic style, as in Vincent Van Gogh's aggressive use of complementary colors in *Starry Night, Café Terrace at Night,* and *The Night Café.* Study oil paintings by greats such as Jan Vermeer, Edgar Degas, Georges Seurat, Mary Cassatt, and Henri Matisse to examine the way these artists utilized color. Look for trends within their bodies of work, and think about the way the colors affect you as you view individual paintings. Photograph a series of images inspired by the artist whose use of color appeals to you the most. Think about not only how you can incorporate the hues your chosen artist used but also about how you can parallel his or her use of color to generate a particular atmosphere or emotional experience.

pull your subject out of context

Who or what do you associate with belonging in a kitchen? A bathroom? A church? A carnival? A schoolhouse? Remove a subject from the setting with which it is commonly associated, and place it in an unlikely location. Does the significance of the subject or the setting itself change when the two elements are juxtaposed?

reinforce metaphors with chromatic repetition

Film directors frequently utilize chromatic repetition to establish atmosphere and to bind elements and scenes. In *Vertigo,* for example, Kim Novak's green wardrobe and other elements throughout the film consistently indicate impending dizziness and delirium for protagonist Jimmy Stewart. Similarly, red throughout *The Sixth Sense* connotes a collision between the supernatural and real worlds; virtually all of the ghostly characters in the film appear in red clothing. Try applying these principles to a carefully planned photograph. First, identify an object that will represent your subject in some way. Next, have your primary subject dress in an identical color. Be sure that no other elements in the frame share your chosen hue.

black & white

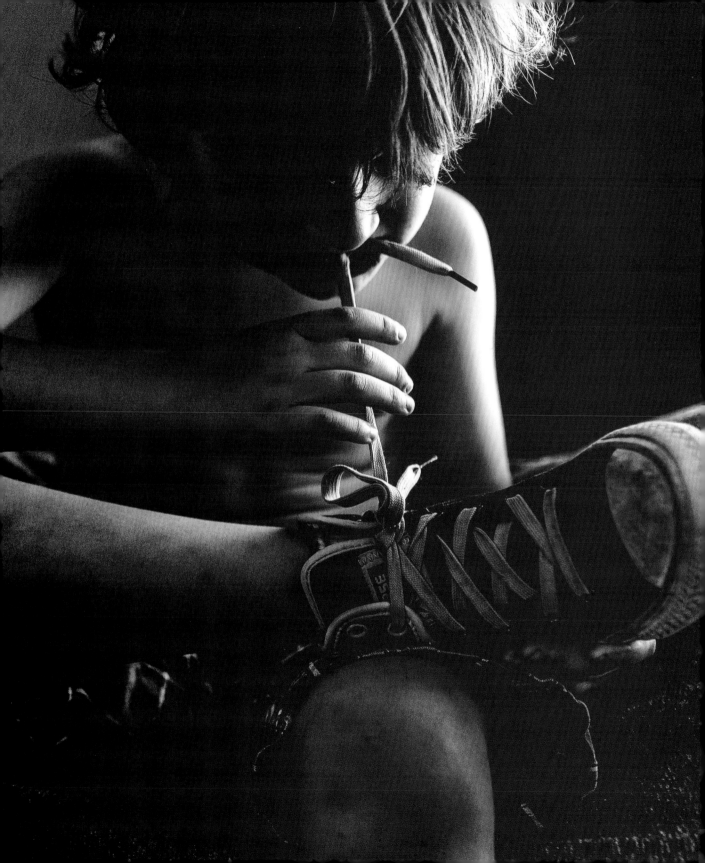

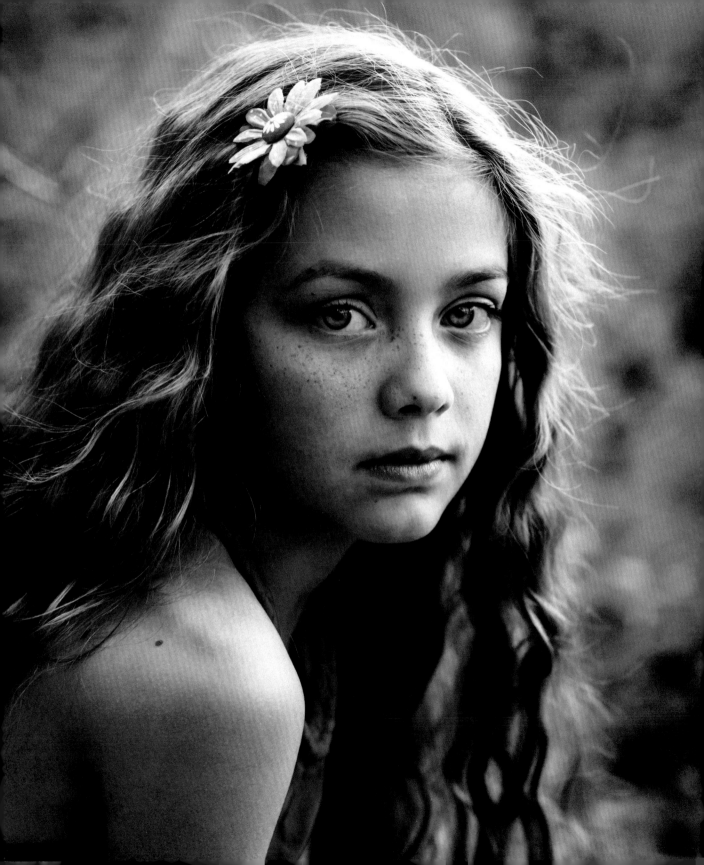

Because we do not see the world in monochrome, black and white does not provide as literal an interpretation of the world around us as does color photography. That alone can give it an artistic edge; the viewer's immediate impression of a black-and-white photograph is that it depicts something in a way that we don't see it every day. By converting to monochrome, photographers can also strengthen the expression of other compositional elements that might otherwise be unable to compete with the powerful element of color. Learning to visualize in black and white means beginning to view the world anew in terms of lines, shapes, textures, and tonality.

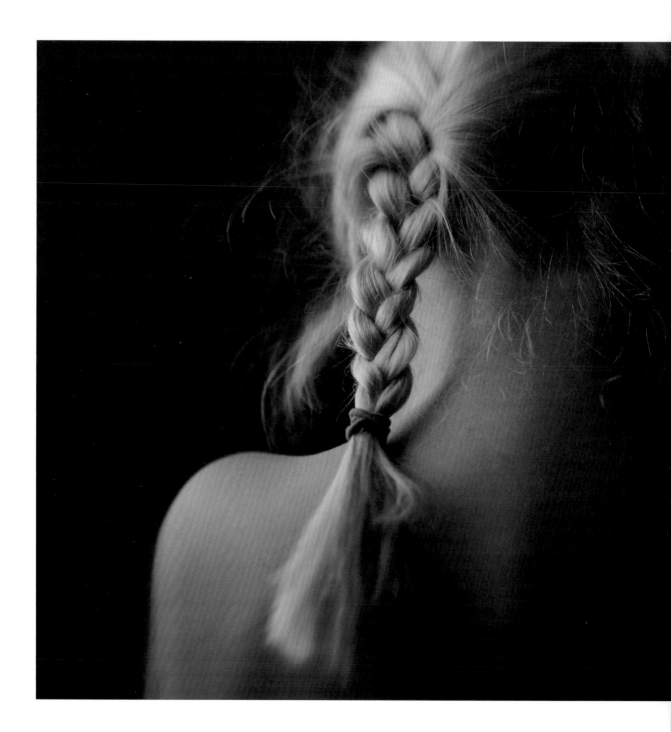

get back to basics

Black-and-white photography is ultimately about light versus dark, so high-contrast subjects and scenes tend to yield powerful monochrome photographs. Look for deep shadows adjacent to bright highlights or light subjects against dark backgrounds; the visual contrast captivates the eye.

Elicia Graves | NIKON D800 | 85MM
f/2.0 | 1/500 SEC. | ISO 1600

identify the difference between color contrast and tonal contrast

Training your eye to separate color from tonality is critical to creating beautiful black-and-white images. Fire engine red and grass green, for example, contrast beautifully in color but tend to merge as midtones in black and white. Conversely, luminous blue water and dark blue tiles can create a striking tonal contrast in black and white.

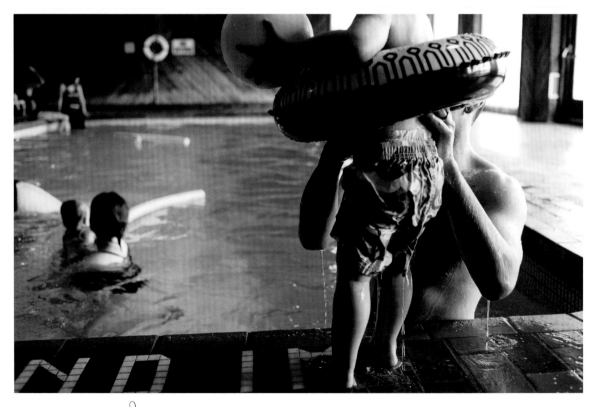

Dana Lauder | NIKON D700 | 35MM | *f*/3.2 | 1/160 SEC. | ISO 400

emphasize timelessness

Reinforce the classic artistry of black-and-white imagery by incorporating timeless elements in the frame. Avoid dating the photo by opting for simple clothing and settings defined by nature or classic architecture that could appear in almost any era.

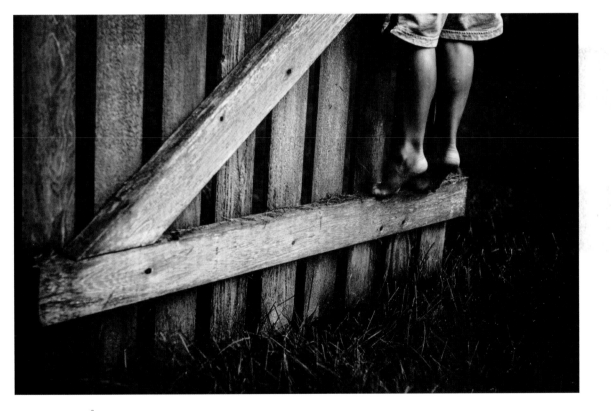

Kristen Ryan | NIKON D800 | 66MM | *f*/5.0 | 1/640 SEC. | ISO 3200

derive inspiration from film noir
and classic cinema

Watch black-and-white films to study the way their directors and cinematographers use light and shadow instead of color to establish mood and create atmosphere.

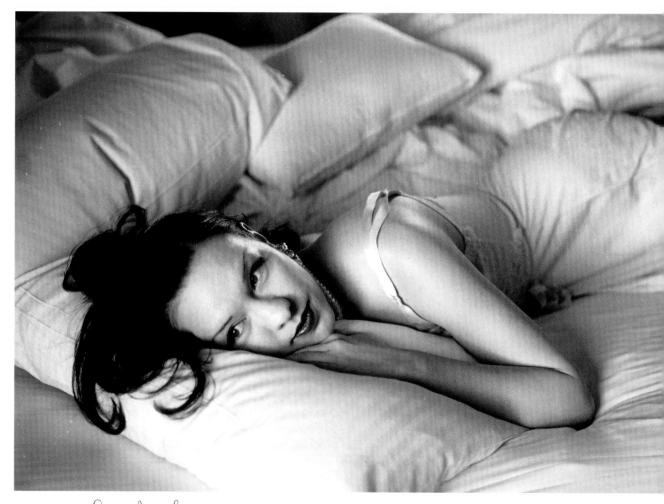

Cheryl Jacobs Nicolai | BRONICA ETRS | 75MM | *f*/2.8 | 1/60 SEC. | ISO 400

seek out scenes with prominent lines

A line is a visual demarcation that extends between two points in the frame. Because tonal contrast defines the existence of a line, strong lines are especially powerful in monochrome. Enhance the tonal contrast between the edges of lines and the areas adjacent to them in order to increase their prominence.

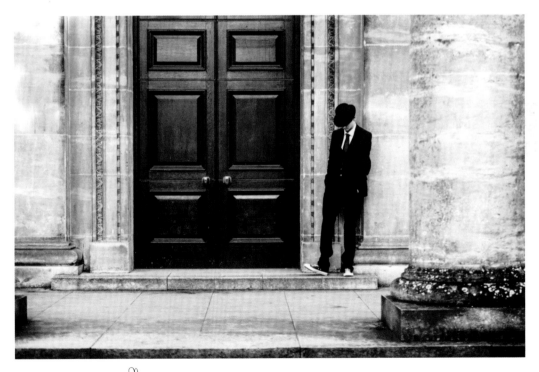

Tracy Bradbury | NIKON D700 | 70MM | f/2.8 | 1/640 SEC. | ISO 400

recognize graphic elements

Color has such a powerful presence that it often overwhelms other image qualities. Line, shape, form, pattern, and texture are often more prominent and more compelling when color is removed, so actively seek out these graphic elements when you approach a scene.

Lisa Tichané | CANON EOS 5D MARK II
24MM | *f*/7.1 | 1/500 SEC. | ISO 160

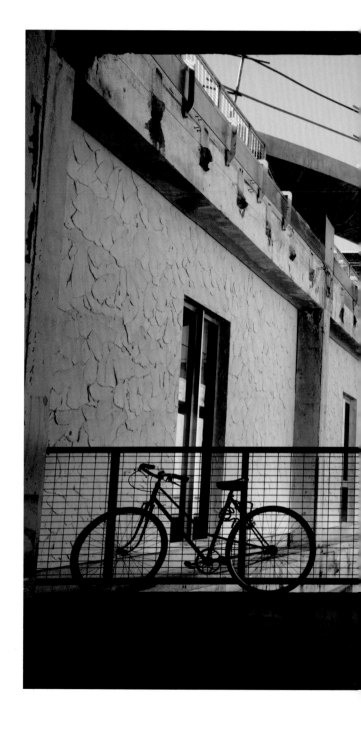

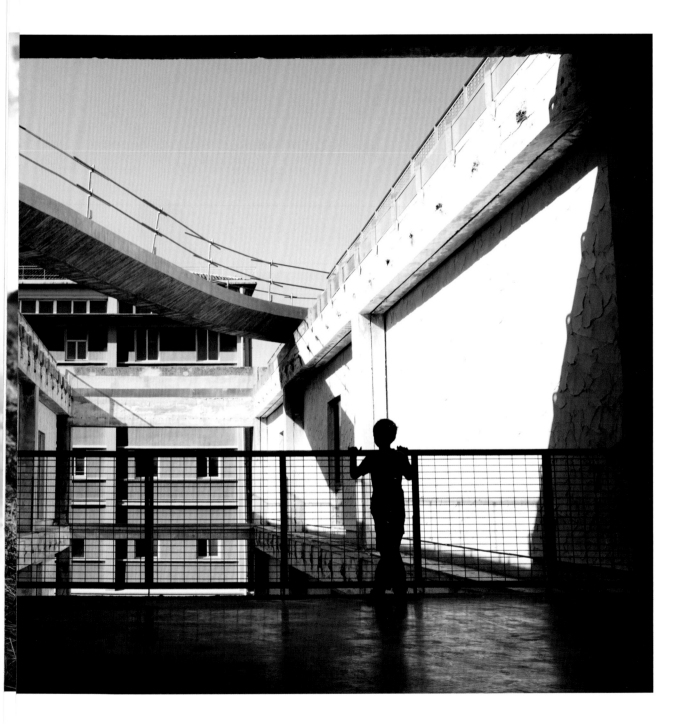

black & white

CREATIVITY EXERCISES

get instant gratification

Set your camera to produce pictures only in black and white. For most DSLRs and point-and-shoot cameras, you can make this change by adjusting your camera's Picture Control or Picture Style settings. Now, when you chimp after each shot, you can immediately see how your scene manifests in monochrome. This is a great way to begin to train your eyes to visualize black-and-white compositions.

utilize directional light

Single-source lighting, especially sidelight, converts well to black and white.
It emphasizes the edges of elements, increases contrast, and enhances textures.

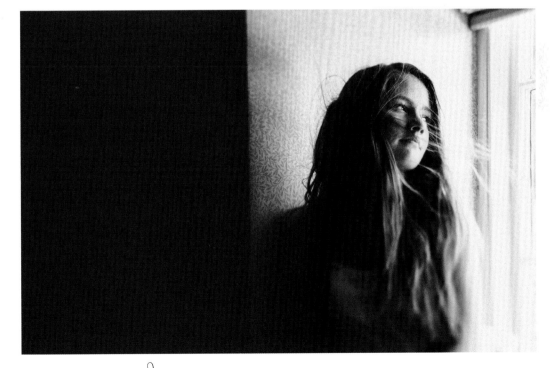

Emma Wood | NIKON D700 | LENSBABY EDGE 80 OPTIC | f/2.8 | 1/800 SEC. | ISO 1600

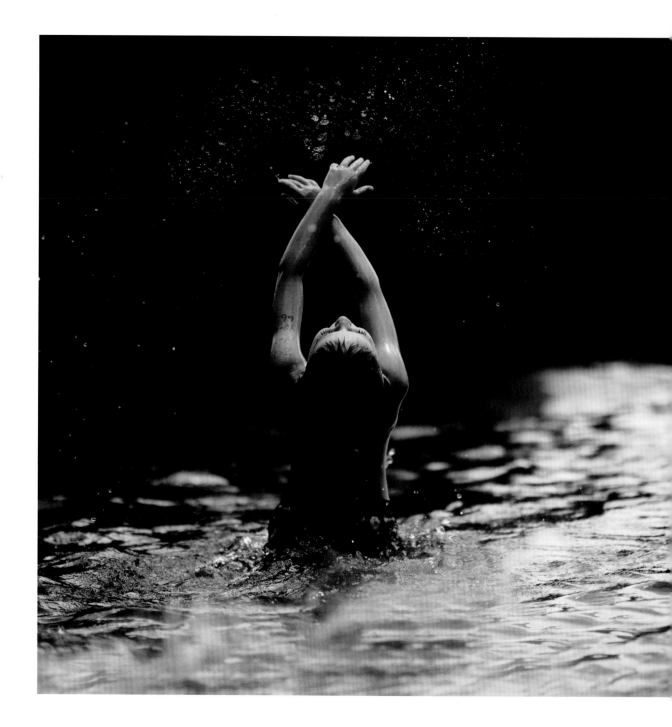

photograph the human form

Artists of all mediums have celebrated the beauty of the human form for centuries. In black and white, the luminosity of skin, curves of the body, and architecture of muscle and frame really shine.

Liz LaBianca | INIKON D4 | 85MM
f/1.4 | 11/8000 SEC. | ISO 200

experiment with angles and placement

You can influence the interplay of light and shadow by adjusting your physical position, your subject's position, or that of your light source. Remember that dramatic tonality manifests particularly well in black and white, so allow yourself to be bold with your inclusion of intense highlight and shadows.

Celeste Pavlik | CANON EOS 5D MARK III
35MM | *f*/2.5 | 1/2000 SEC. | ISO 320

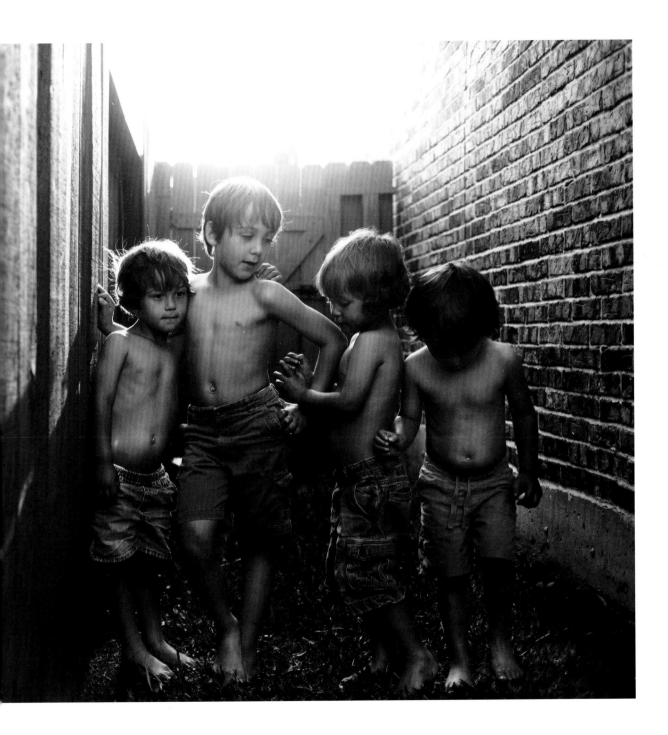

embrace harsh light

Don't be afraid of harsh light. Outside, direct sunlight creates hard shadows that offer plenty of opportunity to create high-contrast images.

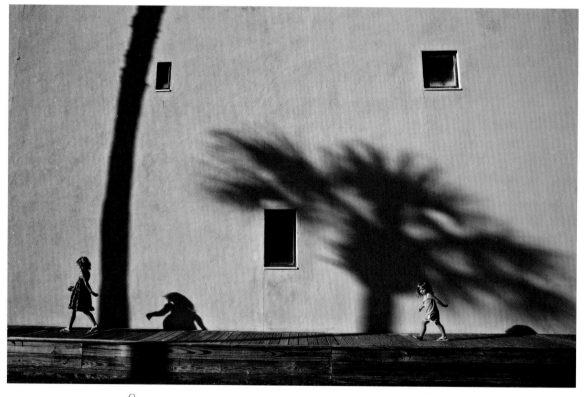

Kate T. Parker | NIKON D700 | 28MM | *f*/8.0 | 1/400 SEC. | ISO 100

work in low light

Low-light settings are often characterized by minimal light encroaching on a predominantly dark scene. The resulting highlights directly adjacent to deep shadows exhibit powerful tonal separation. Converting such an image to black and white allows that tonal interplay to dominate without the distraction of color.

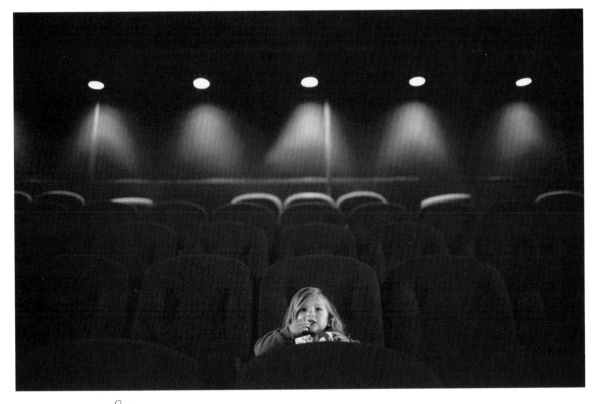

Jo Clark | CANON EOS 5D MARK III | 35MM | ƒ/1.4 | 1/80 SEC. | ISO 3200

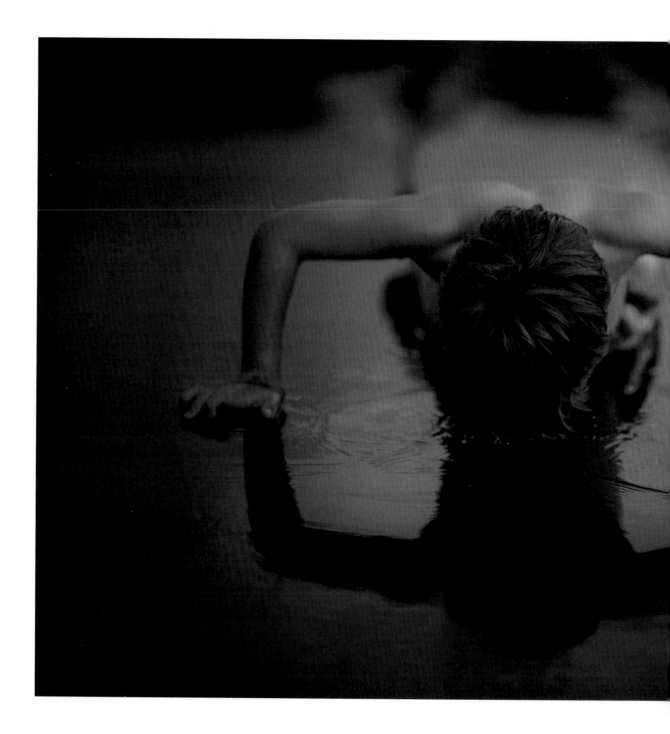

underexpose for creative effect

As with black-and-white photography in general, creatively deep underexposures are a wonderful way to present the world in a way in which people don't usually perceive it. Expose subjects and scenes to appear much deeper than what one would see with the naked eye. This can bring forth rich details and textures that would appear unremarkably sun washed in a standard color exposure.

Heather Rodburg | NIKON D700 | 85MM
f/1.4 | 1/800 SEC. | ISO 1600

simplify your frame

Employ minimalism to highlight basic compositional components. Black-and-white photography is often more successful if you balance simple elements against a clean background.

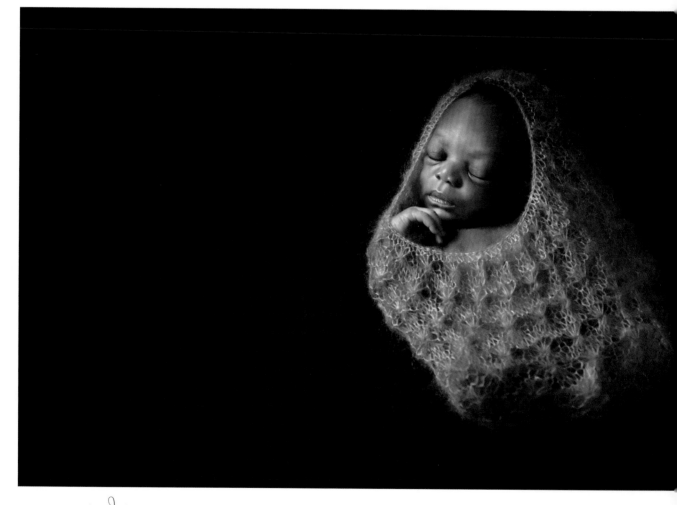

Frayda Breitowitz | NIKON D700 | 35MM | *f*/4.0 | 1/200 SEC. | ISO 100

pursue timelessness

Centuries of black-and-white photographs capture important details of the past and the ways life has changed, but equally striking are photographs of the people and places captured on black-and-white film that look not so very unlike the people and places we encounter today. Set out to create black-and-white photographs that illustrate scenes and subjects that transcend time. When we strip away contemporary wardrobes, modern architecture, and technology, things begin to appear much as they did a century ago. Find a timeless setting—get back to nature or locate a simple corner in your house—and bring a subject into the scene in simple or classic clothing: a white tank top, a cotton dress, a button-down shirt. Remember, too, that your perspective can help to control any distractingly modern elements in the frame; shoot your subject from the back, from overhead, from the neck up, or from the waist down.

go to the movies

In 1989, film critic Roger Ebert wrote an essay entitled "Why I Love Black & White" (*Awake in the Dark,* University of Chicago Press), stating, in part, "Black-and-white movies present the deliberate absence of color. This makes them less realistic than color films (for the real world is in color). They are more dreamlike, more pure, composed of shapes and forms and movements and light and shadow. Color films can simply be illuminated. Black and white films have to be lighted. With color, you can throw light in everywhere, and the colors will help the viewer determine one shape from another, and the foreground from the background. With black and white, everything would tend toward a shapeless blur if it were not for meticulous attention to light and shadow, which can actually create a world in which the lighting indicates a hierarchy of moral values." Watch (or look up film stills from) some of the films to which Ebert refers: *Casablanca, Notorious, It's a Wonderful Life, Night in the City*; or watch some of your own favorite classic black-and-white movies. Study the way they showcase light, shadow, and design elements. Photograph an image inspired by one of these classic films.

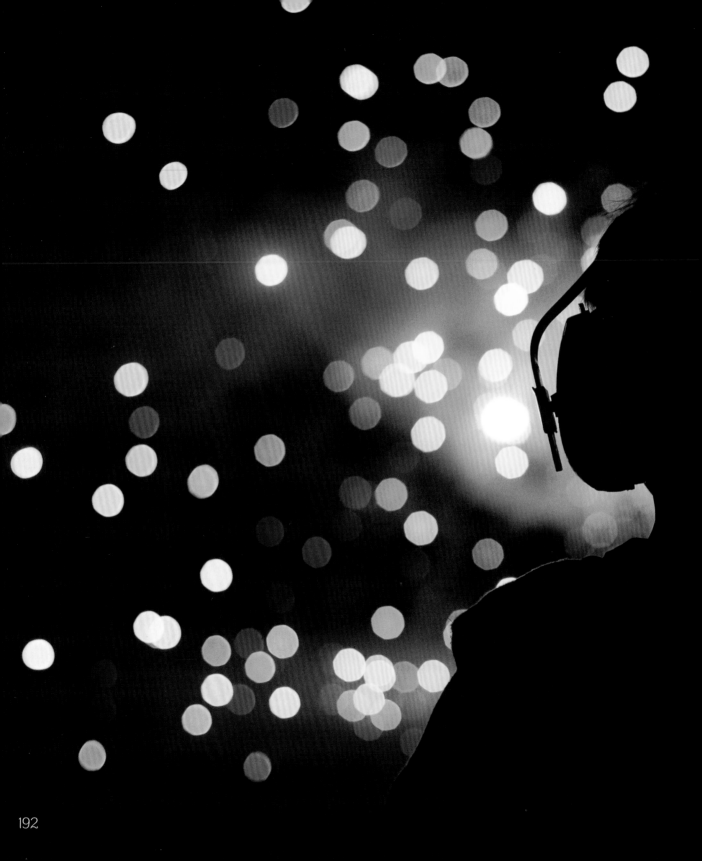

CHAPTER 6

low light

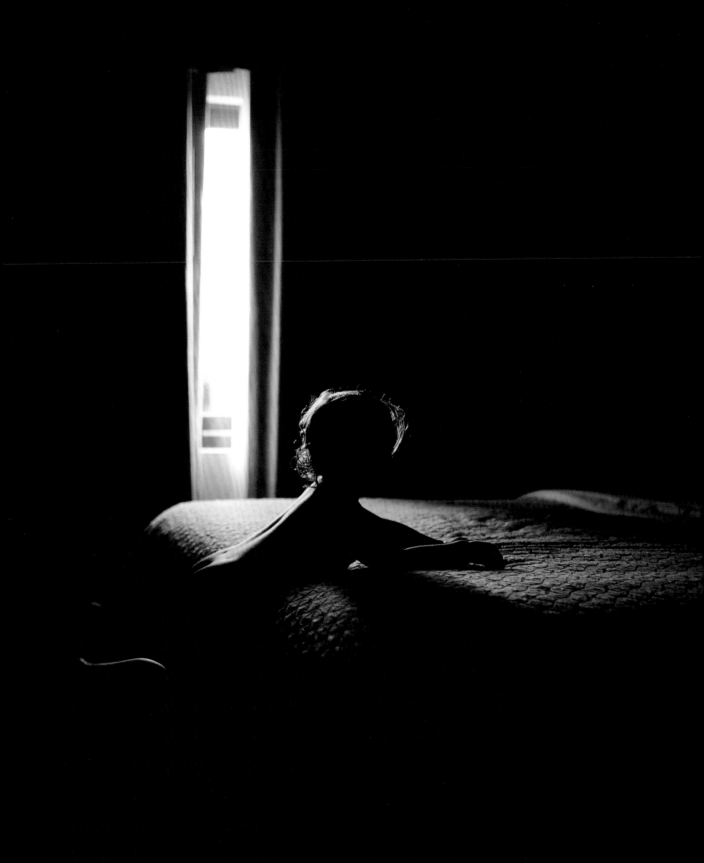

What is low-light shooting? It's likely to be an evolving definition as technological innovations allow cameras to capture high-quality imagery with less and less light, but generally speaking, low-light scenarios are those in which the availability of ambient light is so limited that the photographer must make significant trade-offs as to ISO, shutter speed, and/or aperture in order to achieve a proper exposure. As a result, many photographers put down their cameras when light is scarce. The fact is, however, that low-light scenarios afford photographers a wonderful opportunity to photograph the world in a way that is less commonly captured.

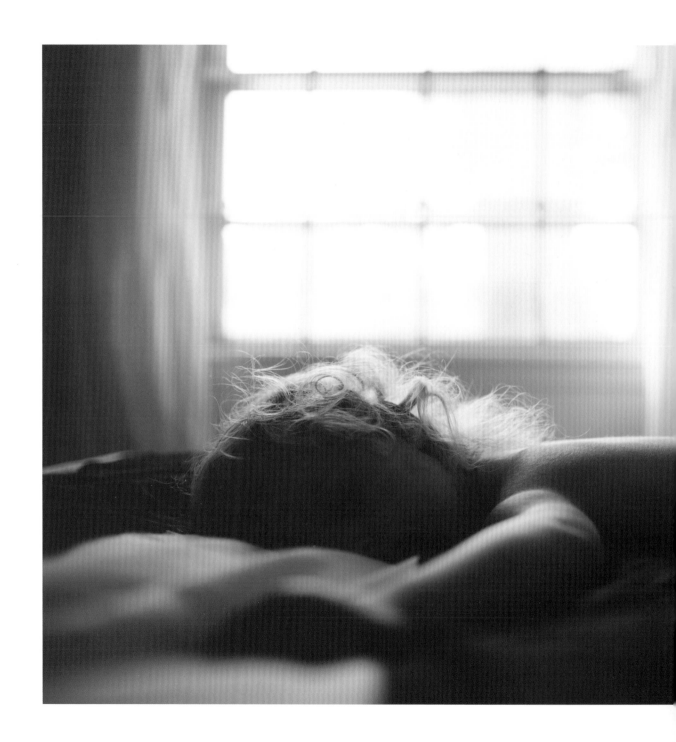

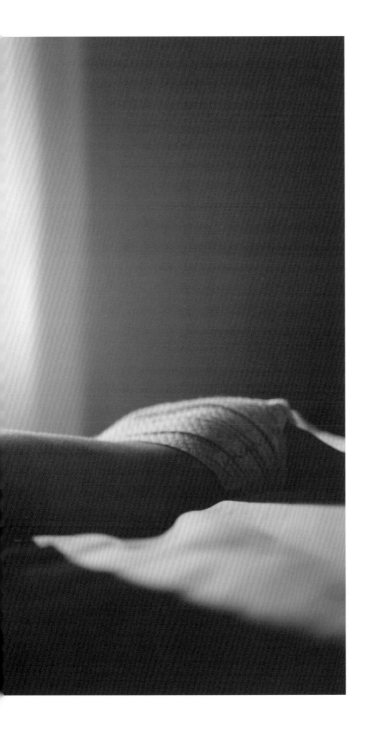

you don't have to stay up late

Low-light photography includes but is not limited to night photography. It may also include interior rooms in which the light is obscured by blinds or curtains, dark forested areas, or enclosed structures with small windows. Scout your city or even your home for deep pockets of shadow during the day.

April Nienhuis | CANON EOS 5D MARK II
35MM | *f*/2.2 | 1/125 SEC. | ISO 400

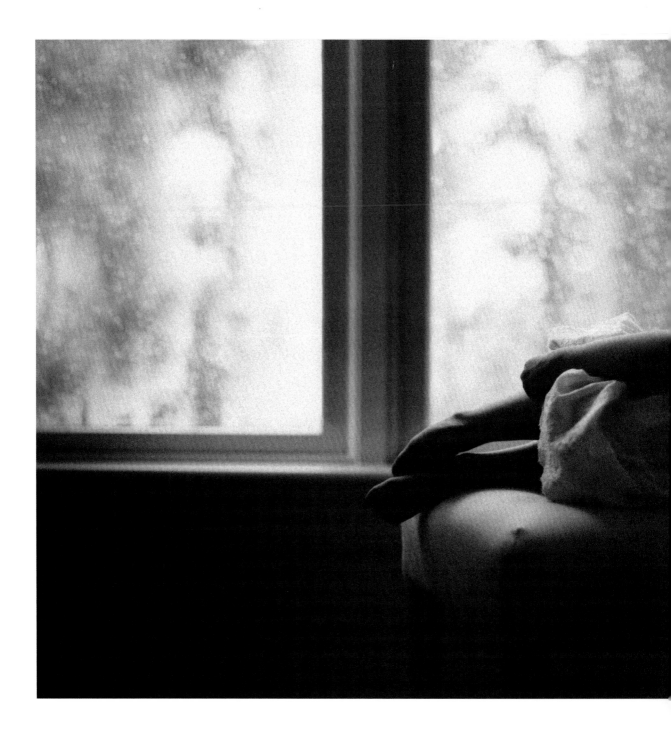

increase your ISO

After selecting your preferred shutter speed and aperture, you may find that a proper exposure in a low-light situation requires you to significantly boost your ISO. Don't get hung up on the number; focus on artistically correct exposure for your subject or scene. As counterintuitive as it may seem, you will have a much cleaner image if you shoot at a high ISO than if you try to brighten a lower-ISO photograph after the fact.

Annie Morris | CANON EOS 5D MARK II
50MM | *f*/1.4 | 1/200 SEC. | ISO 6400

stabilize your camera

A sturdy tripod is a must when you're working with very slow shutter speeds, because the camera will capture every vibration that occurs between the time the shutters open and close. As a general rule, you can handhold at shutter speeds as slow as the inverse of your focal length, so if you're shooting with a 100mm lens, stabilize your camera at shutter speeds slower than 1/100 sec.

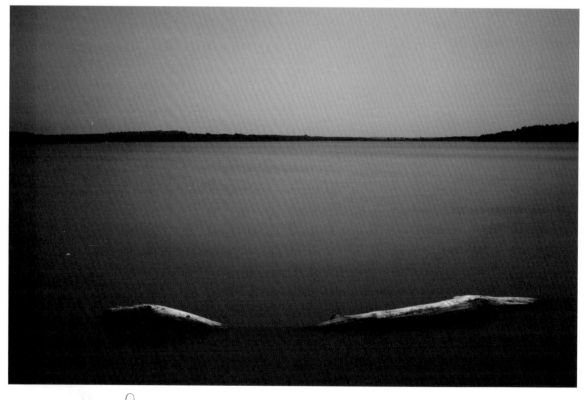

April Nienhuis | CANON EOS 5D MARK II | 35MM | *f*/22 | 5 SEC. | ISO 50

shoot wide open

Shooting "wide open" means using the largest aperture your lens permits. Larger apertures allow you to shoot with faster shutter speeds; however, keep in mind that just because you can shoot at f/1.4 doesn't mean that you should do it all the time. Depending on your focal length and your distance from the subject, large apertures can produce exceedingly shallow depths of field. As when shooting scenes with an abundance of light, you still need to ensure that all necessary elements are in focus and consider what aperture best suits your vision.

Kelly Rodriguez | NIKON D700 | 50MM | f/1.8 | 1/200 SEC. | ISO 1250

expose for your subject

Identify your primary subject and decide the extent to which you are going to lift that subject from the shadows in a low-light setting. This may mean revealing only a sliver of light that wraps around your subject's figure, planning to shoot a silhouette, or exposing for full subject illumination. Peek at the LCD preview on the back of your camera as you shoot to see how your exposure choices influence the mood of the photograph and the details obscured or revealed.

Sarah Carlson | NIKON D800 | 28MM
f/1.8 | 1/800 SEC. | ISO 4000

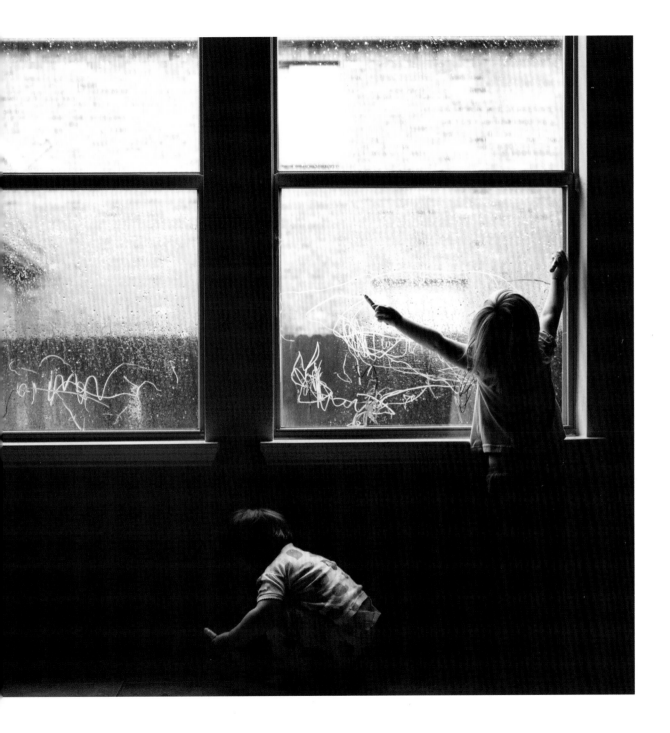

shoot the lights themselves

The beauty of night shooting is that when darkness dominates, a wonderful shot is awaiting anywhere light exists. Worry less about particular subjects, and simply shoot interesting lighting patterns or color arrays.

Stacey Vukelj | CANON EOS 5D MARK III | 135MM | f/5.0 | 1/200 SEC. | ISO 12800

focus manually

When shadow engulfs a subject, it's common for a camera's autofocus system to fail to grab focus. Switch to manual focus, and gently rotate the focus ring on your lens to achieve focus on your own. Sometimes it's hard to ascertain if you've achieved perfect focus, especially in shadowy, low-contrast environments, but you can zoom in to 50 to 100 percent to check focus on the back of your LCD after you take your shot.

Erin Pasillas | NIKON D700 | 50MM | f/2.0 | 1/200 SEC. | ISO 6400

know your color temperatures

Nailing your color in camera is the best way to ensure optimum exposure, so it's helpful to set your white balance manually. Indoor lighting often tricks the camera's automatic white balance and yields unattractively warm hues. Memorize a few basic color temperatures common in low light: moonlight (4000 K), common household bulbs (3000 K), and candlelight (2000 K).

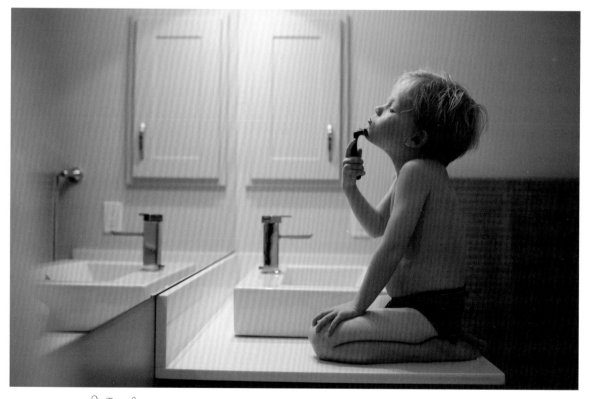

Ardelle Neubert | CANON EOS 5D MARK III | 35MM | *f*/2.2 | 1/160 SEC. | ISO 1000

avoid underexposure

As long as you don't blow your highlights, it's better to expose too brightly than to underexpose. You can always darken your exposure in post-processing without sacrificing image quality, but once you have to increase your exposure in post-processing, the quality degrades, especially at high ISOs.

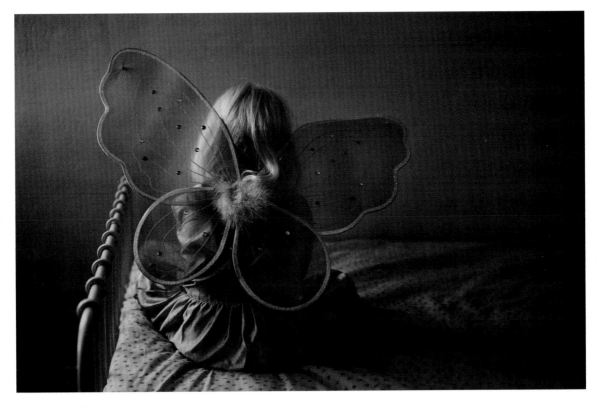

Elicia Graves | CANON EOS 5D MARK II | 35MM | *f*/2.2 | 1/125 SEC. | ISO 2500

explore unconventional light sources

Don't rule out nontraditional light. Light from the refrigerator, light from a computer screen, traffic lights, night-lights, car headlights, fire, and flashlights can all be used to create beautiful low-light images. Turn out all of the main lights in your house one evening and take note of other—usually smaller—light sources that shine through the darkness.

Danielle McIlroy | NIKON D700 | 50MM
f/4.0 | 1/250 SEC. | ISO 500

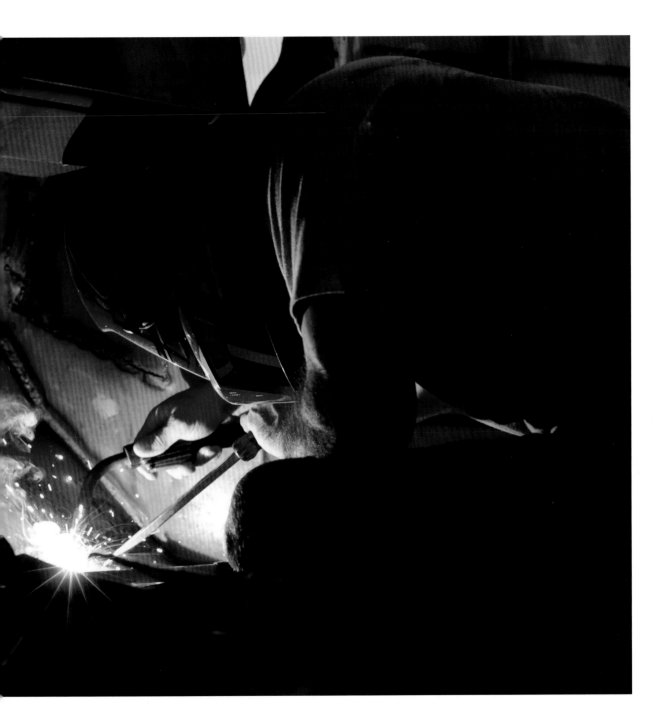

seek out a single small light source for drama

The smaller and farther away the light source relative to your subject, the harder the light. In an overwhelmingly dark setting, a single small light source cutting through the shadows yields hard, dramatic, directional light with a sharp line between highlight and shadow.

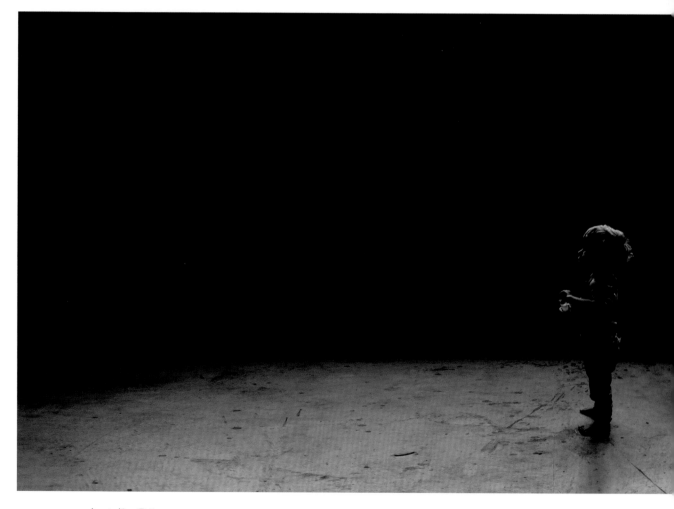

Angie Fox Ortiz | NIKON D7000 | 35MM | ƒ/2.8 | 1/250 SEC. | ISO 320

avoid mixed lighting

If your light is dim, it's tempting to add another light source, such as turning on the overhead lights in a room when minimal natural light is coming in through a window. Be sure that any supplemental lighting is the same color temperature as the existing light or sufficient to completely overpower it, otherwise it will be very difficult to obtain attractive neutral tones in the image.

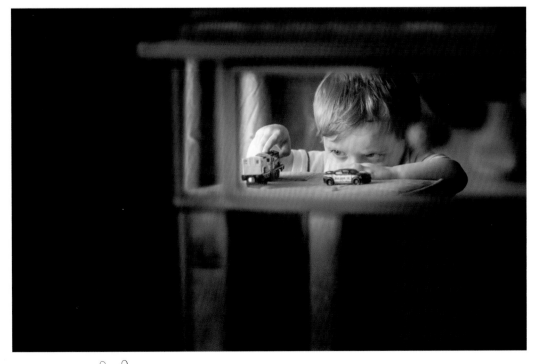

Beth Wade | NIKON D600 | 100MM | *f*/3.0 | 1/250 SEC. | ISO 720

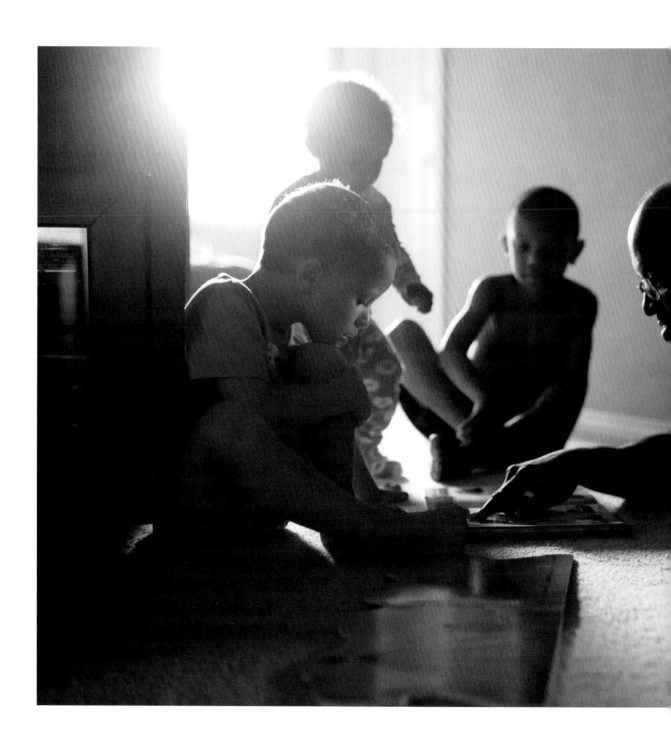

convert to black and white

Monochrome is a popular choice for processing the high-ISO images that typify low-light shooting. This is partly because the inherent "artsiness" of black and white seems more forgiving, and it is partly because black-and-white conversion tends to unify elements in the scene and minimize the noise (graininess) inherent in high-ISO settings.

Jennifer Bogle | CANON EOS 6D | 35MM
ƒ/1.8 | 1/160 SEC. | ISO 10000

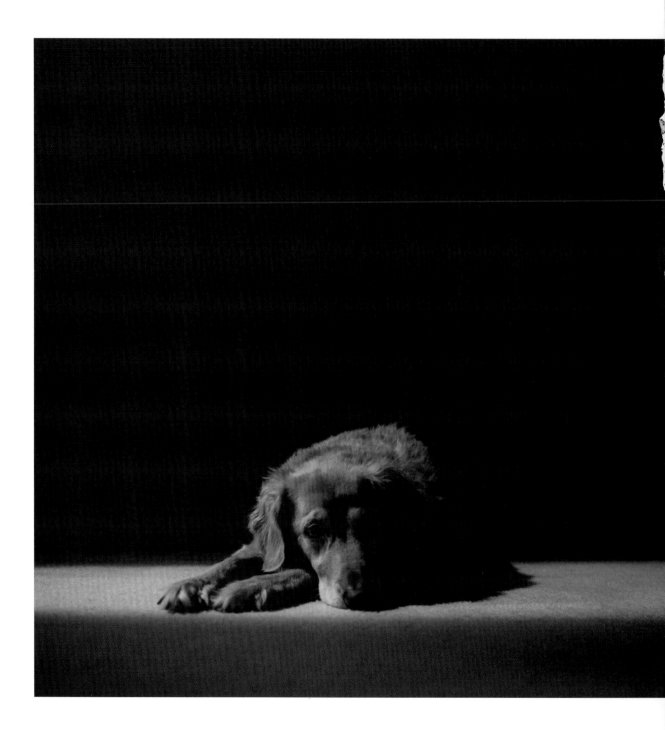

just breathe

If you don't have a tripod available and find yourself needing to handhold your camera at slow shutter speeds, take your cue from military fundamentals of marksmanship: find a steady position, focus and compose, shoot between breaths, and gently depress the shutter button to minimize camera shake.

Sarah Carlson | NIKON D800 | 28MM
f/2.2 | 1/50 SEC. | ISO 5000

experiment with motion blur

Allow the limitations of low-light shooting to become opportunities for creative experimentation. If you can't use a shutter speed fast enough to stop motion, try incorporating motion blur for artistic effect. This technique can be particularly effective to showcase contrast between moving and stationary subjects or to demonstrate hauntingly blurred "ghosting."

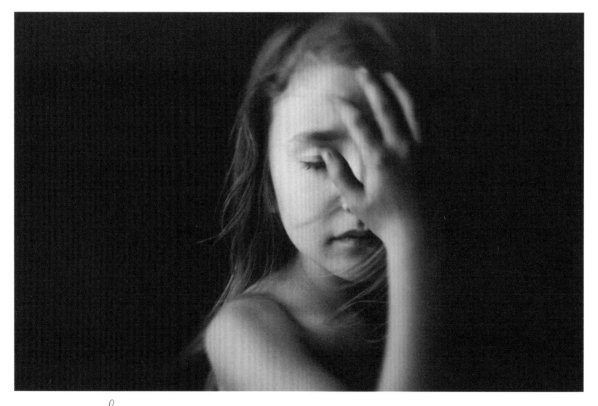

Caroline Jensen | CANON EOS 5D MARK II | LENSBABY EDGE 80 OPTIC | *f*/2.8 | 1/50 SEC. | ISO 4000

shoot for mood

Dark scenes naturally have heavy visual weight and may call to mind emotional depth as well. Think about how the darkness can be applied to possible stories you might tell or atmosphere you might convey. Drama, sadness, intimacy, serenity, mystery, and fear are just some of the moods that viewers may associate with visual darkness. Try approaching your scene with one or more of these feelings in mind.

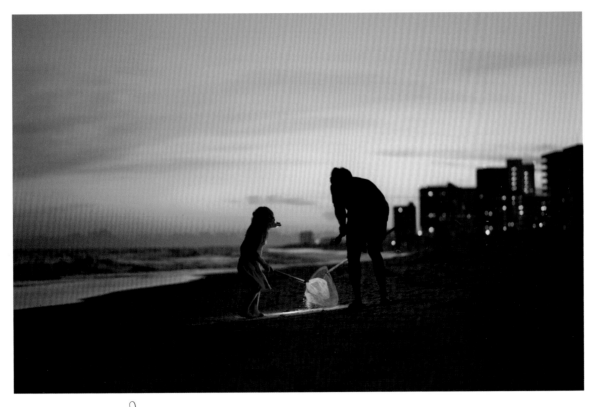

Lauren Sanderson | NIKON D600 | 85MM | ƒ/1.8 | 1/200 SEC. | ISO 2500

know the lunar cycles

In the week surrounding a full moon, early evening tends to be brighter because moonrise is earlier. Whether you're shooting past the Golden Hour or in full moonlight, the three days leading up to, during, and the three days after the appearance of a full moon (which occurs approximately once each month) are particularly great times to shoot after hours.

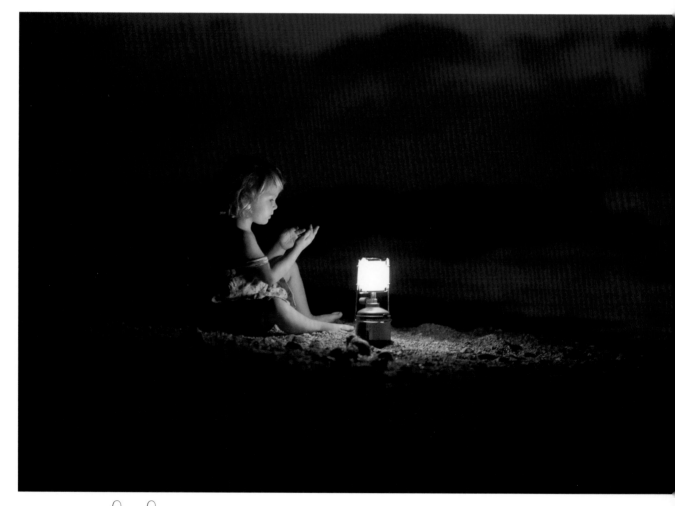

Sarah Vaughn | NIKON D700 | 85MM | ƒ/1.8 | 1/320 SEC. | ISO 6400

seek out luminous subjects

As in full-light situations, bright subjects and surfaces—including pale skin, water, snow, sand, and open book pages—reflect light off of their surfaces and onto surrounding objects. In a low-light setting, the result is especially dramatic, and reflective objects seem almost to glow within a shadowy scene.

Marissa Gifford | NIKON D700 | 200MM | *f*/2.8 | 1/160 SEC. | ISO 2000

fall in love with small windows

Windows funnel light and reduce broad sunlight and diffused moonlight into beams of light. Like small light sources generally, smaller windows produce a more defined and dramatic penetration of darkness. Spot metering is essential in these lighting situations; otherwise, your camera is likely to overexpose the shadows that dominate the scene.

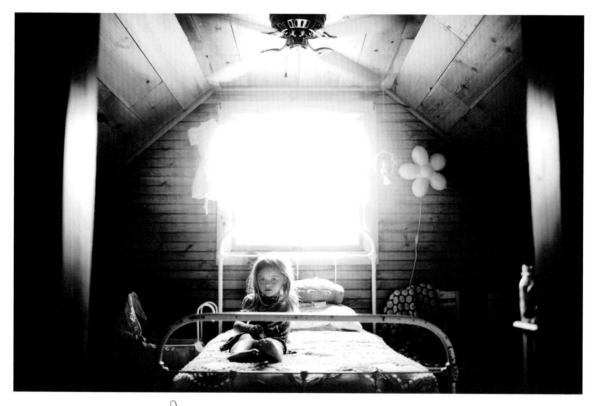

DeAnna McCasland | NIKON D700 | 35MM | ƒ/1.4 | 1/160 SEC. | ISO 250

take advantage of inclement weather to add suspense and visual interest

There's a reason that mysteries are set on "a dark and stormy night" or "once upon a midnight dreary." Fog and rain establish a particularly moody element in low light, obscure the clarity of night, and can also enhance long exposures.

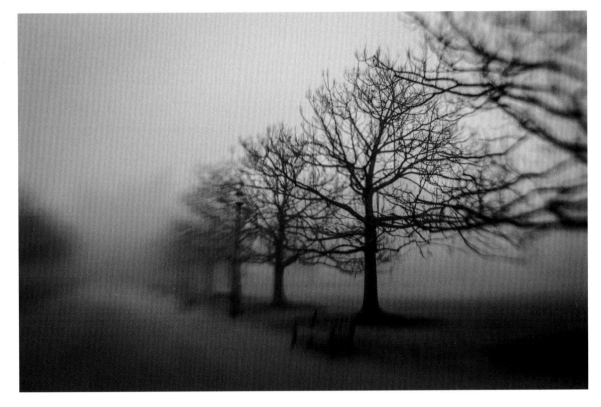

Nina Mingioni | CANON EOS 6D | LENSBABY SWEET 35 OPTIC | ƒ/2.8 | 1/200 SEC. | ISO 800

low light

CREATIVITY
EXERCISES

encourage midnight snacks

Refrigerator light is a wonderful introduction to unconventional low-light photography. Turn off all of the lights in your kitchen, and prompt your subject to open the refrigerator door. Soft, diffused light will wrap around the figure. Expose for the illuminated side of the subject, and let the rest of the scene fall away in shadow. Don't have a cooperative subject with which to try this out? Again, turn out the lights and throw open the fridge; then simply shoot the way the light spills out into the empty kitchen scene itself.

get comfortable with high iso

Many photographers regard the digital noise (graininess) that accompanies high-ISO digital photography as unattractive or undesirable; however, an image need not be pristine to be beautiful. Think about the subjects, emotions, or stories that might even be strengthened by foregoing polish and perfect clarity. How can you use the grittiness and rawness of high-ISO photography to your advantage? Spend a week with your camera set to the highest ISO available to you, and embrace digital noise under both standard and low-light conditions as you ease into images that may look a bit different than your normal shooting style.

watch everything that moves

Photographing motion blur is about more than documenting subjects on the go. Pause for a moment and think about everything that moves as you go about your evening. Capture the motion of conversation and consumption at a dinner table illuminated by candlelight. Capture the motion of a restless sleeper over the duration of several minutes. Capture the movement of clouds pulled like soft cotton across the sky on a windy evening. Capture a moving (literally!) self portrait as you brush your teeth, wash your face, or comb your hair in anticipation of retiring for the night. Capture pencil movement during handwriting exercises in the completion of nightly homework. Set up a tripod or otherwise stabilize your camera if you are shooting exposures longer than about 1/30 sec. in order to ensure that the motion you're capturing is actual subject motion, not camera shake.

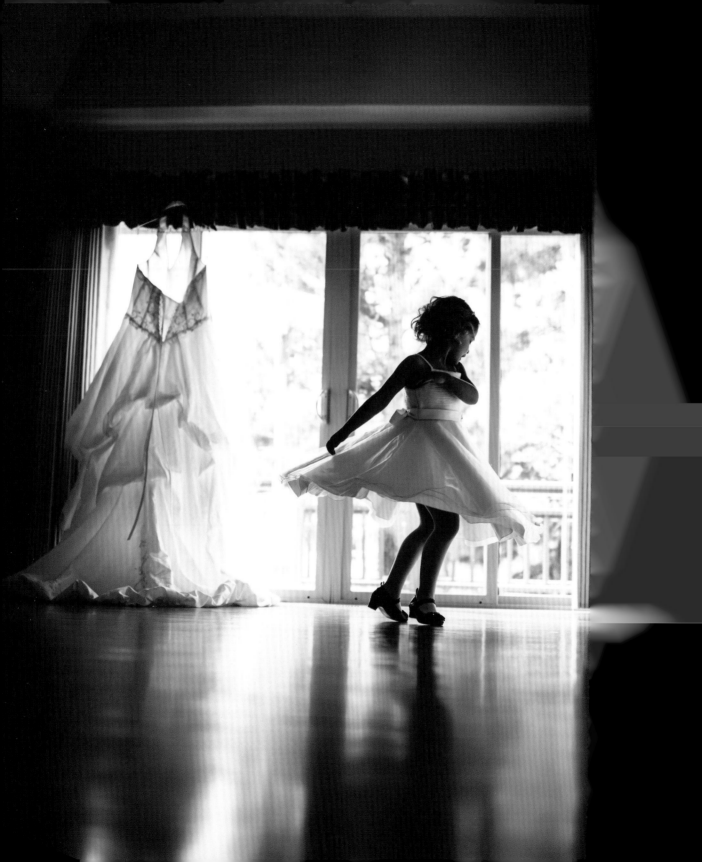

technically speaking

APERTURE Aperture refers to the opening in a lens through which light passes to the camera's sensor or film. The size of the aperture is determined by *f*-stops, with higher *f*-stop numbers indicating smaller aperture openings and lower *f*-stop numbers indicating larger aperture openings. A large aperture opening allows a great deal of light to pass through the lens and yields a shallow depth of field (the plane of sharp focus from front to back in an image). A small aperture opening allows less light to pass through the lens and produces greater depth of field.

APERTURE PRIORITY Aperture Priority is a semiautomatic exposure setting in which the photographer selects an *f*-stop and the camera selects a corresponding shutter speed to yield an optimum exposure. Aperture Priority is useful for situations in which the photographer wishes to take control of the depth of field in shooting. *See also* Exposure Mode.

BOKEH Bokeh refers to the aesthetic quality of a photograph's blurred area and is often described in terms of shape, softness, or smoothness. Bokeh appears in images with shallow depth of field and is most visible around blurred points of light created by direct light or on reflective surfaces.

CHIMPING Chimping is an industry colloquialism that refers to the act of reviewing digital image previews on a camera's LCD screen. Chimping is useful not only to double-check the success of a composition but also to inspect image white balance, histograms, or focus.

DEPTH OF FIELD Depth of field refers to the range of focus extending in front of and behind a selected focal plane. Shallow depth of field indicates that only a sliver of focus is present (a narrow plane). Great depth of field suggests a broader plane of focus from foreground to background.

DIGITAL NOISE Noise is unwanted brightness and color variation among pixels in a digital image that is often seen as a grainy texture in the image. Like film grain, digital noise is most prominent in high-ISO images, but most photographers regard film grain as vastly more appealing than digital noise. Noise/grain filters in Lightroom, Photoshop, or other photo-processing platforms can help to mask and improve the appearance of digital noise in high-ISO photographs.

DSLR DSLR is an acronym for digital single-lens reflex, indicating a digital camera with interchangeable lenses.

EVALUATIVE METERING *See* Metering Mode.

EXPOSURE Exposure refers to the amount of light that reaches a camera's film or digital sensor. Generally speaking, an underexposed image is too dark, an overexposed image is too

bright, and a correctly exposed image exhibits roughly the same level of brightness as the real scene.

EXPOSURE MODE Modern cameras are capable of setting exposure automatically. In full auto mode, the camera adjusts depth of field and shutter speed as needed for optimum exposure. Semiautomatic exposure modes (such as Program mode, Aperture Priority, or Shutter Priority) allow the photographer to determine selected options, such as how much of the scene is in focus or how fast the camera fires, but the camera chooses the overall exposure. Manual exposure mode allows the photographer to select the desired combination of aperture, shutter speed, and ISO directly, which also gives the photographer complete control over exposure.

EXPOSURE TRIANGLE The Exposure Triangle refers to three factors that determine image exposure: aperture, shutter speed, and ISO. In order to maintain a consistent exposure, any change in one factor will require a proportional change in one, or a combination, of the other two. For example, if you increase the shutter speed by 1 stop, you must open up the aperture by 1 stop or increase the ISO by 1 stop in order to preserve your exposure.

FIELD OF VIEW Field of view refers to the area of a scene that is visible within the frame. Photographers sometimes use this term interchangeably with "angle of view" or "field of vision." Wide-angle lenses have a broader field of view than do telephoto lenses. For example, an ultrawide fish-eye lens may have a field of view of 180 degrees, whereas an 85mm lens only has a field of view of about 30 degrees.

FOCAL POINT As a technical matter, the focal point refers to the sharpest or most defined area of a photograph. Focal point may also refer to the most important subject or a critical area to which a photographer intends to draw the viewer's eye within an image.

FOCUS Focus refers to the adjustment of a lens necessary to achieve clarity on a particular subject or within a particular point in the frame. Focus may also refer to the clarity, definition, or sharpness of a photograph or subject within the photograph.

FOCUS MODE Your choice of subject will help to determine which of your camera's autofocus settings you should use. If you're photographing a stationary or very cooperative subject such as a portrait, landscape, or still life, single autofocus (often called AF-S or Single Servo) is a good choice. If you're photographing a moving or erratic subject, such as sports or children on the move, continuous autofocus (often called AF-C or Continuous Servo) may be more effective.

f-**STOP** *f*-stop denotes a lens's aperture setting and is indicated by an *f* number. If you want the foreground, middle ground, and background to all be in focus (as when shooting a landscape), shoot at a higher *f*-stop, such as *f*/16. If you want to isolate a limited plane of focus (such as a single subject against a blurry background), shoot at a lower *f*-stop, such as *f*/2.8.

GOLDEN RATIO The Golden Ratio of 1:phi (or 1:1.618) is the basis for the Golden Rectangle, whose short-to-long side ratio appears as 1:1.618. Many highly regarded compositional frameworks begin with a Golden Rectangle. The Golden Triangle framework, for example,

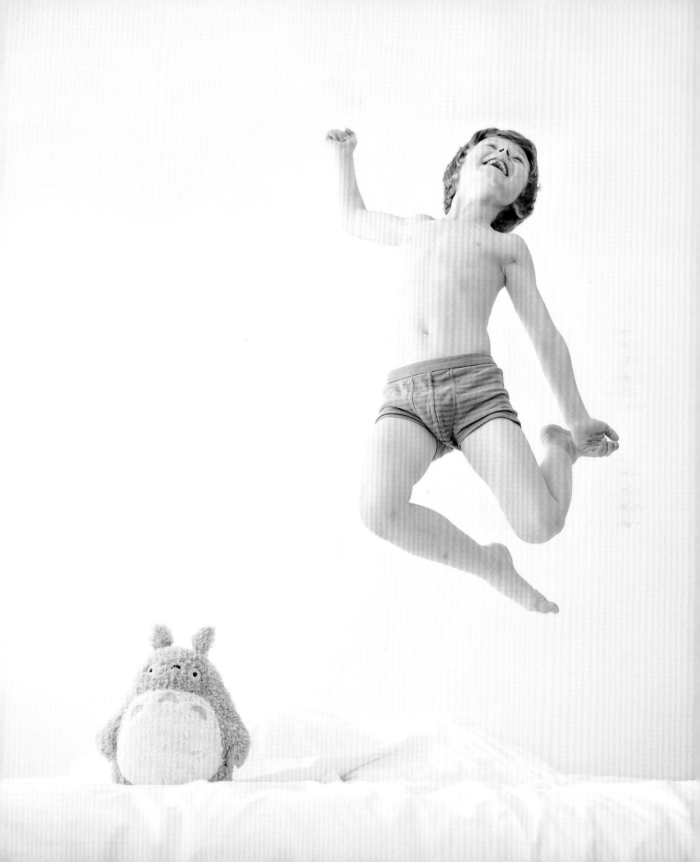

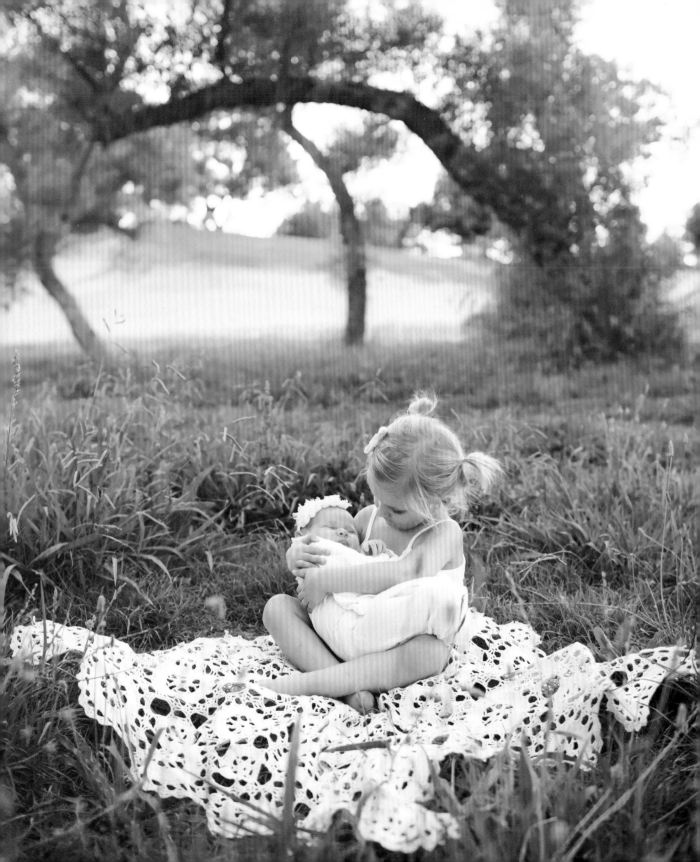

is a Golden Rectangle subdivided by triangles whose base-to-side ratio is expressed as 1:1.618. The Golden Spiral framework is a Golden Rectangle subdivided into a series of Golden Rectangles and squares, with the arc of the spiral turning inwards along each of these divisions.

Golden Triangle

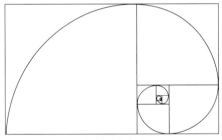

Golden Spiral

HISTOGRAM A histogram is a bar graph that represents the distribution of image pixels across 255 numerical values. Use your camera's histogram display to check your exposure in difficult lighting situations, especially those in which there are both deep shadows and bright highlights. As long as you don't have any of your RGB channels climbing the wall of either end of the histogram (pixel values

at 0 or 255), you know that you have preserved all of your image data. Pay particularly close attention to your histogram highlights when photographing people. The red channel in skin and hair is typically the first to be clipped, especially in those with very fair skin or light-colored hair.

ISO ISO is an acronym for the International Organization for Standardization (commonly referred to as International Standards Organization), and in the field of photography, it refers to the light sensitivity of a digital camera sensor or camera film. A lower ISO indicates less sensitivity, produces less film grain or digital noise, and is appropriate in situations of abundant light. A higher ISO indicates greater sensitivity to light, produces more film grain or digital noise, and is frequently necessary to produce proper exposure in low-light situations.

KELVIN Kelvin, abbreviated simply (K), is a unit of measurement that represents color temperature values. *See also* White Balance.

MACRO Macro lenses are capable of capturing subjects close-up and producing images that are life-size, or a 1:1 photographic reproduction of the subject's actual physical measurement.

MANUAL EXPOSURE Manual exposure refers to the photographer's direct selection of aperture, shutter speed, and ISO combinations. Manual exposure gives photographers much greater control over image tonality and allows them to determine just how bright or deep the overall scene should appear. *See also* Exposure Mode.

MANUAL FOCUS Manual focus refers to disabling the camera's autofocus function and

instead obtaining focus by physically rotating the focus ring with the hand. When photographers refer to "shooting in manual," they are typically referring to manual exposure, not manual focus.

MATRIX METERING *See* Metering Mode.

METERING Metering refers to the way in which photographers determine exposure, usually with a handheld light meter or the camera's built-in light meter.

METERING MODE A camera's metering mode determines the way in which the camera evaluates exposure in a given scene. Evaluative (also known as matrix) metering permits the camera to consider the tonal distribution of the entire frame to determine optimum exposure. Spot metering permits the camera to base exposure only on a small area beneath the focal point or within the center of the frame, depending on your camera.

OVEREXPOSURE *See* Exposure.

SHUTTER PRIORITY Shutter Priority is a semiautomatic exposure setting in which the photographer selects a shutter speed and the camera selects a corresponding aperture to yield an optimum exposure. Shutter Priority is useful for situations in which the photographer wishes to take control of the length of time the camera records motion. Choose a very fast shutter speed to freeze motion or a very slow speed to imply movement in the form of motion blur. *See also* Exposure Mode.

SHUTTER SPEED Shutter speed refers to the amount of time that a camera's shutters are open. A fast shutter speed indicates that the shutters open and close instantly, exposing the camera's film or digital sensor to light for a very short period. A slow shutter speed indicates that the shutters are open for a much longer time, allowing light to hit the camera's film or digital sensor for a longer period. The camera captures all movement that occurs between the time that the shutters open and the time they close.

SLR SLR is an acronym for single-lens reflex, a film camera with interchangeable lenses.

SPOT METERING *See* Metering Mode.

STOP A stop is a unit that measures the ratio of light that reaches a camera's film or digital sensor. Each full stop represents twice as much light as the previous stop. Photographers may adjust any or all components of the Exposure Triangle (aperture, ISO, and shutter speed) in terms of stops. There is a full stop between ISO 100 and ISO 200, for example, with ISO 200 being twice as sensitive to light as ISO 100.

UNDEREXPOSURE *See* Exposure.

WHITE BALANCE Changing the white balance on a digital camera is the process by which photographers adjust color temperature, typically to ensure that pure white objects do, in fact, appear white under various lighting conditions. White balance can also be applied creatively, such as to render a scene warmer or cooler than neutral in order to establish a particular mood. Photographers may set white balance manually, using camera presets such as Daylight or Tungsten, with the camera's auto white balance (AWB) functionality, or by setting custom white balance (CWB) with a gray card.

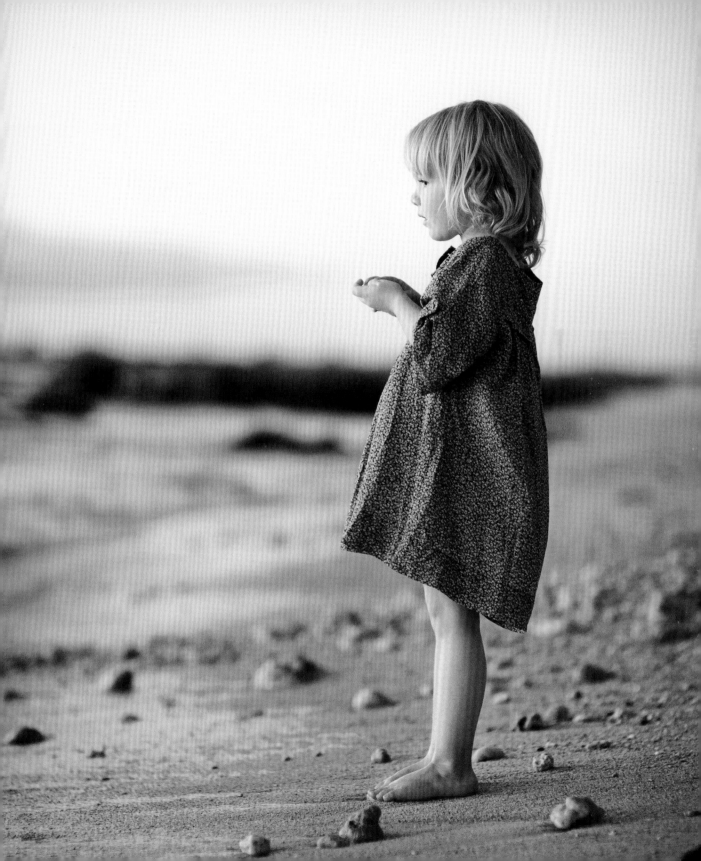

contributor directory

Lauren Ammerman

Jodi Arego

Megan Axelsson

Jennifer Bebb

Liz Behm

Tiffany Bender

Lisa Benemelis

Carly Bingham

Meg Bitton

Elena S. Blair

LAUREN AMMERMAN is a photographer located in Dallas. Her wedding and senior portrait work can be found at www.laurenammermanphoto.com. See page 55. Contributor photo by Misti Davis.

JODI AREGO is a photographer located in Houston. Her personal projects and portrait work can be found at www.jodiarego.com. See page 98. Contributor photo by Jodi Arego.

MEGAN AXELSSON is a photographer located in Chicago. Her personal and commissioned work can be seen at www.meganaxelsson.com. See pages 139 and 152. Contributor photo by Megan Axelsson.

JENNIFER BEBB is the director of CMpro as well as an author, photographer, and cofounder of the What If the Conference. You can find her online at www.bebbstudios.com. See page 77. Contributor photo by Steve Bebb.

LIZ BEHM is a photographer in Columbus, Mississippi. Currently a happy hobbyist, her personal projects can be found at www.lizbehm.com. See page 90. Contributor photo by Liz Behm.

TIFFANY BENDER of Munchkins and Mohawks strives to work with available light to create fantastic visuals that are better than real life. Her work can be found at www.munchkinsandmohawks.com. See page 108. Contributor photo by Tiffany Bender.

LISA BENEMELIS is a natural-light photographer who resides in Northern California. Her work can be found at www.lisabenemelis.com. See page 150. Contributor photo by Lisa Benemelis.

CARLY BINGHAM is a family and portrait photographer located in the Los Angeles area. Her business and personal work can be found at www.carlybingham.com. See page 187. Contributor photo by Carly Bingham.

MEG BITTON is a photographer specializing in children's portraiture in the New York City area. Her work can be found at www.megbitton.com. See pages 41 and 62. Contributor photo by Meg Bitton.

ELENA S. BLAIR is a portrait photographer in Seattle specializing in fine art documentary portraiture, with a focus on families and newborns. Her work can be found at www.elenasblairphotography.com. See page 116. Contributor photo by Bre Thurston.

ELIZABETH BLANK is an award-winning newborn, child, and family photographer located in the Atlanta area. Her work can be found at www.elizabethblankphotography.com. See page 59. Contributor photo by Elizabeth Blank.

JENNIFER BOGLE is a photographer located in Blaine, Washington. Her client work along with some of her favorite personal projects can be found at www.jenniferboglephotography.com. See page 213. Contributor photo by Jennifer Bogle.

RENEE BONUCCELLI is a photographer in St. Albert, Alberta, Canada. Her personal projects, highlighting her family, fine art, and everyday beauty, can be found at www.reneebonuccelli.com. See page 30. Contributor photo by Renee Bonuccelli.

TARYN BOYD, owner of Blu Hippo Photography, is a Pittsburgh-based natural-light portraiture photographer specializing in maternity, newborn, children, and families. Her work can be found at www.bluhippophotography.com. See page 32. Contributor photo by Taryn Boyd.

TRACY BRADBURY is a photographer located in Ashley Green, England. She photographs children, teens, and macro. Her work can be found at www.tracybradbury.com. See page 179. Contributor photo by Tracy Bradbury.

CAROLYN BRANDT is a film and digital lifestyle photographer living in Los Angeles. You can see her personal projects and client work at www.carolynbrandtphotography.com. See page 56. Contributor photo by Carolyn Brandt.

FRAYDA BREITOWITZ is the owner of FeeBee Photography, a fine-art portrait studio located in Columbia, Maryland, where she creates heirloom-quality photographic art. View her online gallery at www.feebeephotography.com. See page 178. Contributor photo by Frayda Breitowitz.

BEIRA BROWN is a portrait photographer in Reading, Pennsylvania. She specializes in newborns, children, and families. Her work can be found at www.beirabrown.com. See page 12. Contributor photo by Beira Brown.

APRIL BURNS is a photographer who loves taking photos of her boys on their small farm under the beautiful Oklahoma skies. Her work can be found at aprilburnsphotography.wordpress.com. See page 82. Contributor photo by April Burns.

SARAH CARLSON is a hobbyist photographer in McKinney, Texas. She captures her children's daily lives and shares her work at www.sarahcarlsonphoto.com. See table of contents and pages 203 and 214. Contributor photo by Sarah Carlson.

Elizabeth Blank

Jennifer Bogle

Renee Bonuccelli

Taryn Boyd

Tracy Bradbury

Carolyn Brandt

Frayda Breitowitz

Beira Brown

April Burns

Sarah Carlson

Jill Cassara

Shalonda Chaddock

Lissa Chandler

Megan Cieloha

Jo Clark

Sarah Cornish

Melissa Deakin

Megan Dill

Kristin Dokoza

Juliette Fradin

JILL CASSARA is a photographer located in Ann Arbor, Michigan. Her personal projects can be found at www.jillcassara.com. See page 14. Contributor photo by Jill Cassara.

SHALONDA CHADDOCK of Chubby Cheek Photography is a nationally published child photographer, based out of Houston, where she is drowning in glitter and princess dresses with her family. Her work can be found at www.chubbycheekphotography.com. See pages 87 and 105. Contributor photo by Melissa Anderson.

LISSA CHANDLER is a portrait and wedding photographer based out of northwest Arkansas who loves photographing people as much as her three-year-old loves Batman and her one-year-old loves sneaking Skittles. Her work can be viewed at www.lissachandler.com. See page 149. Contributor photo by Andrew Chandler.

MEGAN CIELOHA is a photographer currently located on the island of Sicily. Her portfolio and current work, featuring personal projects and fine art, can be found at www.megancieloha.com. See page 10. Contributor photo by Megan Cieloha.

JO CLARK is a wedding and portrait photographer serving the Northern California area. Her work can be found at www.bluella.com. See page 175. Contributor photo by Jo Clark.

SARAH CORNISH is a natural-light photographer from Connecticut now based out of Fort Collins, Colorado. She specializes in children and family portraiture, is a mother of five, and is constantly inspired by her children both in photography and in life. Her work can be found at www.myfourhensphotography.com. See pages 25 and 182. Contributor photo by Wesley Cornish.

MELISSA DEAKIN is an on-location, natural-light photographer based just outside of Buffalo, New York. She enjoys photographing newborns, children, families, and pets. Her client work and personal projects can be found at www.melissadeakin.com. See page i. Contributor photo by Melissa Deakin.

MEGAN DILL is a photographer in New York's Hudson Valley. She works primarily with natural light and shoots both film and digital. Her work can be found at www.megandill.com. See pages 136 and 141. Contributor photo by Megan Dill.

KRISTIN DOKOZA is a child and family photographer in the San Francisco area who loves to capture unique light and images filled with emotion. Her work can be found at www.kristindokozaphotography.com. See page 52. Contributor photo by Kristin Dokoza.

JULIETTE FRADIN is a French lifestyle and modern portrait photographer based in Washington, DC. Her work can be found at www.juliettefradin.com. See page 103. Contributor photo byJennifer Dale.

MELISSA GIBSON is a photographer located in the Atlanta area. Her personal work, projects, and family stories can be found at www.melissagibsonphotography.com. See page 157. Contributor photo by Melissa Gibson.

MARISSA GIFFORD is an on-location photographer located in the Portland area. She specializes in families, newborns, and high school seniors. Her client and personal work can be found at www.marissagiffordphotography.com. See pages 78 and 219. Contributor photo by Marissa Gifford.

ALICIA GOULD is a natural-light photographer from New Jersey who specializes in newborn, child, and family photography. Her work can be found at www.aliciagouldphotography.com. See page 133. Contributor photo by Ethan Gould.

ELICIA GRAVES is a photographer located in Berkeley, California. Her personal projects and family work can be found at www.eliciagraves.com. See pages 164 and 207. Contributor photo by Elicia Graves.

LIZA HALL is a photographer located in Maine. Her food, family lifestyle, and portrait work can be found at www.lizahallphotography.com. See pages 109 and 148. Contributor photo by Barb Napoli.

STACEY HASLEM is a photographer located in Modesto, California. Her work can be found at www.staceyhaslem.com. See page 70. Contributor photo by Stacey Haslem.

LISA HOLLOWAY is a natural light portrait photographer in the Las Vegas area. She specializes in maternity, babies, children, families, and high school seniors. Lisa's work can be found at www.ljhollowayphotography.com. See page 162. Contributor photo by Jeff Holloway.

KRISTY HOWELL is a photographer located in Maryborough, Queensland, Australia. Her personal projects and children and family work can be found at www.sweetmillyphotography.com.au. See page 126. Contributor photo by Corinne Tristram.

ADELE HUMPHRIES is a hobbyist photographer based in Katy, Texas, where she focuses on a lifestyle approach to documenting her family. You can view her work at adelehumphriesphotography.wordpress.com. See pages 74 and 119. Contributor photo by Adele Humphries.

KRISTIN INGALLS is a portrait photographer in the Seattle area. She loves using the beautiful Pacific Northwest surroundings in her images. Her work can be found at www.kristiningalls.com. See page 11. Contributor photo by Kristin Ingalls.

Melissa Gibson Marissa Gifford

Alicia Gould Elicia Graves

Liza Hall Stacey Haslem

Lisa Holloway Kristy Howell

Adele Humphries Kristin Ingalls

Jennifer James

Caroline Jensen

Celeste Jones

Jenni Jones

Justine Knight

Liz LaBianca

Sarah Lalone

Kirsty Larmour

Anna Christine
Larson

Dana Lauder

JENNIFER JAMES is a designer and photographer based in Chicago. Obsessed with all things visual, she hasn't stopped making images since a Kodak Disc camera landed in her eight-year-old hands. You can find her work at www.thejameses.com. See page 88. Contributor photo by Jennifer James.

CAROLINE JENSEN is a photographic artist living on the prairie of southwest Minnesota. She shoots both film and digital. You can find her work at www.lovestandsstill.com. See pages 128 and 216. Contributor photo by Caroline Jensen.

CELESTE JONES is a photographer located in Wilmington, Delaware. She shoots both film and digital. Her children and family work can be found at www.celestejonesphotography.com. See page 55. Contributor photo by Celeste Jones.

JENNI JONES is a natural-light photographer specializing in newborn, maternity, and baby photography in the Austin area. Her work can be found at www.jennijonesphotography.com. See page 135. Contributor photo by Jenni Jones.

JUSTINE KNIGHT is a photographer based in Westchester, New York. Her fine art and family work can be found at www.justinesknight.com. See page 144. Contributor photo by Justine Knight.

LIZ LABIANCA is a natural-light lifestyle photographer based in Frisco, Texas. Her fresh, sun-infused work can be viewed at www.lizlabiancaphotography.com. See pages 65 and 170. Contributor photo by Liz LaBianca.

SARAH LALONE is a photographer located in London, Ontario, Canada. Her portrait work, stock photos, and fine art can be found at www.punchphotographic.com. See page 16. Contributor photo by Sarah Lalone.

KIRSTY LARMOUR is a lifestyle photographer based in Abu Dhabi, United Arab Emirates. She is passionate about photographing childhood and captures her own kids traveling around the world. Her work can be found at www.kirstylarmour.com. See pages 4 and 46. Contributor photo by Kirsty Larmour.

ANNA CHRISTINE LARSON is a photographer located in Northern California. She specializes in both documentary wedding photography and family lifestyle sessions. Her work can be found at www.anna-christine.com. See page 92. Contributor photo by Anna Christine Larson.

DANA LAUDER is a hobbyist photographer from Kitchener, Ontario, Canada. Her work can be found at www.danalauder.com. See pages 38 and 166. Contributor photo by Dana Lauder.

TRACY LAULHERE is a photographer based in Southern California. She defines her approach and style as classic, honest, and bold. Her fine art and personal projects are featured at www.tracylaulhere.com. See page 134. Contributor photo by Tracy Laulhere.

HEATHER LAZARK is a passionate photographer based in Northern California. She enjoys capturing the simple beauty of every day and she shares her work at www.heatherlphotography.com. See page 114. Contributor photo by Heather Lazark.

JO LIEN is a lifestyle photographer from Coeur d'Alene, Idaho, where she lives with her husband and two young sons. Jo's work explores the terrain of a life well lived and documents the impermanence of daily life with sincerity. Her work can be found at www.jolienphotography.com. See page 192. Contributor photo by Jo Lien.

AMY LUCY LOCKHEART is a photographer in the Minneapolis area. Her creative, fine art, and commissioned work can be seen at www.amylucy.com. See pages 19 and 146. Contributor photo by Amy Lucy Lockheart.

EMILY LUCARZ is a newborn, child, and family photographer located in St. Louis. Her work can be found at www.emilylucarzphotography.com. See pages 35 and 75. Contributor photo by Sarah-Beth Photography.

ALIX MARTINEZ is a commercial and fashion children's photographer in the New York City and Connecticut areas. Her personal projects include underwater photography silhouettes and a documentary series called *Sundays*. Her work can be found at www.alixmartinez.com. See page 96. Contributor photo by Alix Martinez.

DEANNA MCCASLAND is a natural-light lifestyle photographer in the West Virginia area. Her personal projects and family work can be found at www.deannamccasland.com. See page 218. Contributor photo by DeAnna McCasland.

CORINNE MCCOMBS specializes in newborn and family photography. She is located in the San Francisco Bay Area. Her work can be found at www.corinnemccombs.com. See page 112. Contributor photo by Renee Marie.

CHRISTINA MCGUIRE is a portrait and lifestyle photographer residing in the suburbs of Detroit with her husband, two little girls, and one yappy Yorkie. Her work can be found at www.christinamcguire.com. See page 101. Contributor photo by Christina McGuire.

DANIELLE MCILROY is a hobbyist photographer located in Mountain Home, Idaho. Her personal projects and macro work can be found at www.facebook.com/DanielleMcIlroyPhotography. See pages 142 and 209. Contributor photo by Danielle McIlroy.

Tracy Laulhere

Heather Lazark

Amy Lucy Lockheart

Jo Lien

Emily Lucarz

Alix Martinez

DeAnna McCasland

Corinne McCombs

Christina McGuire

Danielle McIlroy

Sabra McKibbon

Allison McSorley

Nina Mingioni

Carrie Anne Miranda

Sally Molhoek

Megan Moore

Annie Morris

Sarah Morris

Ardelle Neubert

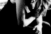

Cheryl Jacobs Nicolai

April Nienhuis

Meredith Novario

SABRA MCKIBBON is a photographer living in Northern California. You can see her work at www.facebook.com/smckibbonphotography. See page 129. Contributor photo by Anastasia McKibbon.

ALLISON MCSORLEY is a photographer located in northern Virginia. Her personal projects and family work can be found at www.allisonmcsorleyphotography.com. See page 106. Contributor photo by Allison McSorley.

NINA MINGIONI is a Philadelphia-based photographer who enjoys cityscape, street, and macro photography. Her work can be found at www.ninamingioni.com. See pages 34, 125, and 219. Contributor photo by Daria Maidenbaum.

CARRIE ANNE MIRANDA is a portrait and wedding photographer from Fresno, California. Her work can be found at www.carrieannemiranda.com. See pages 53 and 228. Contributor photo by Carrie Anne Miranda.

SALLY MOLHOEK is a lifestyle-portrait and wedding photographer located in southeast Michigan. Her work can be viewed at www.sallykatephotography.com. See page 27. Contributor photo by Melanie Reyes.

MEGAN MOORE is an on-location family and wedding photographer in the Boston area. Her work can be found at www.meganjanephotography.com. See page 28. Contributor photo by Megan Moore.

ANNIE MORRIS is a hobbyist photographer located on Cape Cod. She enjoys capturing the everyday moments of her children. Her work can be found at www.annie-morris.com. See page 198. Contributor photo by Annie Morris.

SARAH MORRIS is a portrait photographer located in North Georgia. Her family and children work can be found at www.sweetaquaphotography.com. See page 95. Contributor photo by Sarah Morris.

ARDELLE NEUBERT is a photographer in Calgary, Alberta, Canada. Her work can be found at www.lifeflicks.ca, with personal projects at www.lifeflicks.ca/mylife. See pages 22 and 206. Contributor photo by Brittany Esther Photography.

CHERYL JACOBS NICOLAI works exclusively with black-and-white film. Her photography is inspired by a love of all things vintage and retro, and her work can be found at www.cheryljacobsphotography.com. See page 168. Contributor photo by Shellie Rodgers.

APRIL NIENHUIS is an Oklahoma-based photographer who photographs the details of life from her family to weddings. Her work can be found at www.aprilnienhuis.com. See pages 196 and 200. Contributor photo by Andrea Murphy Photography.

MEREDITH NOVARIO is a photographer living in Okinawa, Japan, thanks to the US military. Her personal work can be found at www.meredithnovario.com. See pages 3, 44, 93, and 115. Contributor photo by Meredith Novario.

KENDRA OKOLITA is the founder of Clickin Moms and a photographer based in Geneva, Illinois. Her personal work can be viewed at www.kendraokolita.com. See page 89. Contributor photo by Amy Wenzel.

ANGIE FIX ORTIZ is a documentary photographer based in San Diego. Her personal work can be found at www.angiefixortiz.com. See page 210. Contributor photo by Angie Fix Ortiz.

KARA ORWIG is an enthusiastic hobbyist photographer. She shoots lifestyle and environmental portraits of her own children. Her work can be found at www.juneandbear.com. See page 20. Contributor photo by Beth Simpkins.

KATE T. PARKER is a family, wedding, fine art, and commercial photographer based in Atlanta. Her work can be found at www.katetparkerphotography.com. See pages 67 and 174. Contributor photo by Alice Parker.

ERIN PASILLAS is a photographer located in Kingsburg, California. Her client work and personal projects can be found at www.erinpasillas.com. See pages 66 and 205. Contributor photo by Erin Pasillas.

CELESTE PAVLIK, a photographer located in central Maryland, shoots primarily black-and-white documentary, fine art, and child portraiture. Her work can be found at www.everydayphotobliss.com. See page 173. Contributor photo by Celeste Pavlik.

KAREN PORTER is a photographer located in Syracuse, New York. Her personal projects and work can be found at www.saltcityart.com. See page ii. Contributor photo by Karen Porter.

CHLOE RAMIREZ is a wedding and portrait photographer located in the Pacific Northwest. She shoots both digital and film. Her work can be found at www.chloephotographygallery.com. See page 25. Contributor photo by Jessica Ho.

ALANA RASBACH is a documentary photographer in Nashville. She specializes in births, children, and families at home. Her work can be found at www.alanarasbach.com. See page 31. Contributor photo by Alana Rasbach.

LEAH ROBINSON is a natural-light photographer based in Melbourne, Australia. Her whimsical family and children's portraiture can be viewed at www.leahrobinsonphotography.net. See page 6 and 138. Contributor photo by Leah Robinson.

HEATHER RODBURG is a child-portrait photographer located in Bethlehem, Pennsylvania. Her portrait work and personal projects can be found at www.heatherrodburgphotography.com. See page 176. Contributor photo by Heather Rodburg.

KELLY RODRIGUEZ is a natural-light photographer located in New York. Her portrait work and personal projects can be found at www.kelly-r.com. See page 201. Contributor photo by Kelly Rodriguez.

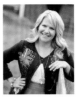 Kendra Okolita

 Angie Fix Ortiz

 Kara Orwig

 Kate T. Parker

 Erin Pasillas

 Celeste Pavlik

 Karen Porter

 Chloe Ramirez

 Alana Rasbach

 Leah Robinson

 Heather Rodburg

Kelly Rodriguez

Kristen Ryan

Lauren Sanderson

Marie Sant

Amber Schneider

Deb Schwedhelm

Meg Sexton

Beth Simpkins

Amelia Soper

Rebecca Spencer

Megan Squires

KRISTEN RYAN is a photographer located in the Chicago area. Her lifestyle and fine art work can be found at www.kristenryanphotography.com. See page 167. Contributor photo by Kristen Ryan.

LAUREN SANDERSON is an available-light photographer in Huntsville, Alabama, who enjoys shooting digital and film. Her personal, portrait, and lifestyle work can be found at www.laurensandersonphotography.com. See page 217. Contributor photo by Lauren Sanderson.

MARIE SANT is a portrait photographer located in Salt Lake City. Her personal and professional work can be found at www.bloomandgrowphotography.com. See page 68. Contributor photo by Marie Sant.

AMBER SCHNEIDER is a lifestyle photographer located in central California. She specializes in documentary wedding and family sessions as well as various personal projects. Her work can be found at www.aschneiderphoto.com. See page 130. Contributor photo by Doug Morgan.

DEB SCHWEDHELM is a fine art photographer, military spouse, and mother to three children, who are often the subjects of her work. Her photographs have been exhibited widely and featured in publications throughout the world. Her portfolio can be found at www.debschwedhelm.com. See pages 51 and 184. Contributor photo by Aplana Aras.

MEG SEXTON is a wedding and lifestyle photographer in the San Francisco Bay Area who is known for her captivating natural-light images. Her work can be found at www.megsexton.com. See page 79. Contributor photo by Volatile Photography.

BETH SIMPKINS is a natural-light hobbyist residing in eastern Kentucky. She enjoys capturing the simple beauty of everyday life. You can see more of her photography at www.bethsimpkinsphotography.com. See page 188. Contributor photo by Kara Orwig.

AMELIA SOPER is a wedding and family photographer in the Seattle area. Her work can be found at www.soperphotography.com. See page 120. Contributor photo by Lucas Anderson.

REBECCA SPENCER is a photographer located in Little Brickhill, England. Her photographic adventures with her young son, Theo, can be found at www.rebeccaspencerphotography.com. See page 113. Contributor photo by Rebecca Spencer.

MEGAN SQUIRES is a natural-light photographer with a focus on newborns and high school seniors in the Sacramento area. Her work can be found at www.megansquires.com. See page 39. Contributor photo by Meg Borders.

KATRINA STEWART is a Scotland-based photographer. Her personal projects, family, and film work can be found at www.katrinastewart.com. See page 153. Contributor photo by Katrina Stewart.

MELISSA STOTTMANN is a newborn, family, and lifestyle photographer in Wilmington, Delaware, and the surrounding areas. Her work can be found at www.melissastottmannphotography.com. See page 102. Contributor photo by Melissa Stottmann.

JESSICA SVOBODA is a documentary photographer located in Syracuse, New York. Her lifestyle photography and wedding work can be found at www.jessicasvobodaphotography.com. See page 84. Contributor photo by Julie Paisley.

CAROL SWAITKEWICH is a family lifestyle photographer living in Winnipeg, Manitoba, Canada, with her husband, three girls, and a dog. Her personal and client work can be seen at www.frecklefacephotography.ca. See pages 61 and 73. Contributor photo by Michele Anderson.

TARAH SWEENEY is a San Diego photographer and lover of light. Her work can be found at www.tarahsweeney.com. See page 99. Contributor photo by Tarah Sweeney.

HOLLY THOMPSON is a photographer residing in Austin. She is currently focused on personal projects and her work can be found at www.hollyanissa.com. See page 60. Contributor photo by Holly Thompson.

BRE THURSTON is a wedding and portrait photographer based in Seattle. Her work can be found at www.brethurston.com. See page 110. Contributor photo by Crissie McDowell.

LISA TICHANÉ is a lifestyle photographer based in Marseille, France, who specializes in children and family portraiture. Her work can be found at www.toutpetitpixel.com. See pages 181 and 227. Contributor photo by Lisa Tichané.

CORINNE TRISTAM is a photographer in Brisbane, Australia. She concentrates on weddings and stylized portraiture. Her work can be found at www.sweetspotimages.com.au. See page 224. Contributor photo by Kristy Howell.

MICHELLE TURNER is a wedding and portrait photographer based in Maine and Pennsylvania. She specializes in destination weddings and environmental portraiture. See more of her work at www.michelleturner.com. See page 69. Contributor photo by Jackson Turner.

Katrina Stewart

Melissa Stottmann

Jessica Svoboda

Carol Swaitkewich

Tarah Sweeney

Holly Thompson

Bre Thurston

Lisa Tichané

Corinne Tristam

Michelle Turner

Ginger Unzueta

Sarah Vaughn

Stacey Leece Vukelj

Beth Wade

Elle Walker

Monica Wilkinson

Kelly Wilson

Tami Wilson

Emma Wood

Katie Woodard

Candice Zugich

GINGER UNZUETA is a natural-light lifestyle photographer located in central Florida. You can learn more about her and her passion for capturing the beauty of every day at www.gingerunzuetaphotography.com. See page 49. Contributor photo by Ginger Unzueta.

SARAH VAUGHN of Story Lane Photography is a portrait photographer in the San Francisco Bay Area who specializes in natural-light photography. You can view her work at www.storylanephotography.com. See pages 8, 218, and 231. Contributor photo by Sarah Vaughn.

STACEY LEECE VUKELJ is located in New York City. Her street photography and other personal projects can be seen at www.vukeljnyc.com. See pages 26 and 205. Contributor photo by Stacey Vukelj.

BETH WADE is a newborn photographer located in Lake Wylie, South Carolina. Her fine art and family work can be found at www.bethwade.com. See page 211. Contributor photo by Beth Wade.

ELLE WALKER is a fine art and documentary photographer located in Victoria, Australia. Her work can be found at www.ellewalker.com. See pages 76 and 189. Contributor photo by Natasha Larsen.

MONICA WILKINSON is a self-taught photographer based out of Seattle. She enjoys shooting children, macro, and fine art photography. You can view her work at www.monicawilkinson.com. See pages 145 and 154. Contributor photo by Lacey Meyers.

KELLY WILSON is a photographer located in Norman, Oklahoma, who specializes in newborn photography. Her personal projects and newborn and family work can be found at www.kellywilsonphotography.com. See page 37. Contributor photo by Kelly Wilson.

TAMI WILSON is a portrait photographer in Denver. She specializes in newborn and baby photography. Her work can be found at www.tamiwilsonphotography.com. See page 121. Contributor photo by Tami Wilson.

EMMA WOOD is a natural-light, film-inspired photographer who resides in the United Arab Emirates. Her personal projects, fine art, and family work can be found at www.emmawoodphotography.com. See pages 21 and 169. Contributor photo by Emma Wood.

KATIE WOODARD is a newborn and family photographer in Flagstaff, Arizona. Her work can be found at www.katiewoodardphotography.com. See page 185. Contributor photo by Katie Woodard.

CANDICE ZUGICH is a natural-light photographer who specializes in fine art portraits and black-and-white imagery. Her work can be found at www.blissfulmavenphotography.com. See pages 160 and 194. Contributor photo by Candice Zugich.

about the author

Duke graduate and former attorney SARAH WILKERSON joined Clickin Moms, the largest organization of female photographers in the world, in 2008 and quickly became a leader in the community. Serving beginner, intermediate, and advanced artists with lively community forums, wide-ranging educational offerings, an online retail store, and a targeted program serving photo professionals, Clickin Moms was named the nation's sixth fastest–growing privately-held media company by *Inc.* magazine in 2013. Clickin Moms also publishes *Click*, an award-winning bimonthly print magazine, and hosts Click Away, an annual photography conference for women.

Together with founder Kendra Okolita, Sarah has led the evolution of the company's mission, program development, and position within the greater photography community. She presently writes *Click* magazine's "Why It Works" feature and instructs CMuniversity's upper-level composition courses. She is also a natural-light photographer who specializes in tilt-shift work; see page 15 and www.sarahwilkerson.com.

Sarah resides in Charlottesville, Virginia, with her Army Judge Advocate General's (JAG) Corps Attorney husband, three sons, one daughter, and two dogs.

index

A

Abstract effects, 142
Adams, Ansel, 185
Anonymity, 114, 151
Aperture Priority, 225
Apertures
 definition of, 225
 larger, 201

B

Backlighting, 27, 29
Balance, 69
Beauty, nontraditional, 132
Black-and-white photography
 characteristics of, 163, 191
 color vs., 186, 191
 converting colorful subjects
 to, 145
 creativity exercises for, 190–91
 experimenting with angles and
 placement in, 172
 Golden Hour in, 183
 graphic elements in, 180
 of the human form, 171
 inspiration for, 168, 191
 lighting for, 169, 174–75
 lines in, 179
 low-light shooting for, 175, 213
 minimalist, 178
 post-processing for, 188–89
 setting camera for, 190
 skies in, 184
 timelessness of, 167, 191
 tonal contrast in, 165–66, 172,
 179, 185, 188–89
 underexposures in, 177
 visualizing scenes for, 163, 185, 190
Body language, 107, 123
Bokeh, 225
Burning, 189

C

Camera stabilization, 200, 215, 223
Cartier-Bresson, Henri, 80
Cassatt, Mary, 159
Catchlights, 13
Centering, 78
Chimping, 190, 225
Chromatic repetition, 155, 159
Clarity, 77
Close-ups, 115, 142
Colors
 artistic style and, 158–59
 complementary, 71, 159
 psychological effects of, 156
 repetition of, 155, 159
 tonality vs., 166
Color temperature
 experimenting with, 43
 settings for, 33, 206, 230
 of supplemental lighting, 211
Composition
 balance and, 69
 centering, 78
 complementary colors and, 71
 creativity exercises for, 80–81
 definition of, 47
 diagonal lines and, 68
 environment and, 54, 81
 filling the frame, 54
 foreground elements and, 63
 geometric shapes and, 74
 Golden Ratio and, 79, 226, 229
 horizon lines and, 51
 improving, 47
 internal frames and, 61
 leading lines and, 66–67
 of minimalist vs. detailed
 images, 57
 minimizing distractions in, 58
 negative space and, 60
 patterns and, 75
 previsualizing, 97
 Rule of Thirds, 48
 size and scale in, 72, 81
 subject placement and, 76, 78
 from subject's eye level, 52
 texture and, 77
 from unusual vantage points, 53
 visual progression and, 64
Conflict, 89, 138
Creativity exercises
 for black-and-white
 photography, 190–91
 for composition, 80–81
 for fine art photography, 158–59
 for low-light photography, 223
 for natural light, 43
 for storytelling, 122–23

D

Defocusing, 140, 142
Degas, Edgar, 159
Degeneration and decay,
 images of, 152
Depth of field
 aperture and, 201
 definition of, 225
Details, importance of, 57, 104, 115
Diagonal lines, 68
Digital noise, 225
Directional light, 23, 169, 210
Distractions, minimizing, 58, 99
Dodging, 189
Doorways, 17, 29
Dream journals, 158
DSLR, definition of, 225

E

Ebert, Roger, 191
Emotions
 anticipating, 111
 in dark scenes, 217
 exploring, through
 photography, 137
 full range of, 112
Environment, inclusion of, 54, 81
Epilogues, visual, 121, 123
Exposure
 definition of, 225–26
 manual, 229
 setting, in advance, 94
 See also Overexposure;
 Underexposure
Exposure mode, 226